LOCATION FILMING IN
ARIZONA

LOCATION FILMING IN
ARIZONA

THE SCREEN LEGACY OF THE GRAND CANYON STATE

LILI DEBARBIERI

Charleston — London

THE
History
PRESS

Published by The History Press
Charleston, SC 29403
www.historypress.net

Copyright © 2014 by Lili DeBarbieri
All rights reserved

First published 2014

Manufactured in the United States

ISBN 978.1.62619.063.4

Library of Congress CIP data applied for.

Notice: The information in this book is true and complete to the best of our knowledge. It is offered without guarantee on the part of the author or The History Press. The author and The History Press disclaim all liability in connection with the use of this book.

CONTENTS

PREFACE

When the credits of a film roll, I wait patiently to the end, intrigued to find out where the movie shot. Movie-related tourism and sites—Monument Valley, where Forrest Gump ends his cross-country journey; North Carolina's Chimney Rock State Park, which appears in *The Last of the Mohicans*; and downtown Tucson's Chicago Music Store, featured memorably in Martin Scorsese's *Alice Doesn't Live Here Anymore* with its charismatic yellow-and-black signage—bring added meaning and dimension to these locales. You are transported through the filmmaker's version and interpretation of a place at a particular moment in time. Movie travel allows a viewer to see a place anew through the emotions and tone that the film inspires, whether suspense, horror, adventure, drama or wonder. Suddenly, movies filmed on location in Arizona seem to be popping up everywhere. On television, there is an endless parade of films and shows—including *Little House on the Prairie*, *A Kiss Before Dying*, *Can't Buy Me Love* and *Traffic*—and so many were filmed in and near my hometown of Tucson alone.

With respect to moviemaking, just what are locations? Locations are simply the places or sites at which a movie, television show or commercial film. More importantly, they "establish the locale, the overall look, texture and the emotional and visual pulse of a film," shared Timothy Flood, a Tucson-based locations manager. Often a viewer's first and last image, the location can be more memorable and expressive than even the stars or script of the film—it can be a secondary character.

In Arizona, a location may be a cactus forest, a lovely stretch of highway scenery, towering granite cliffs or urban environments. Locations are nearly synonymous with landscape in Arizona—the rolling grasslands of Santa Cruz and Cochise County, the forest and red rock country of the north, with many of the state's city-based historical locations in a precarious existence.

There is an intense amount of public fascination with the decades between the 1930s and the 1960s. Because of this, moviegoing audiences are, in turn, fascinated with the pop culture of that time, most fully captured and represented in films. The western genre during filmmaking's iconic golden age coincided with this time. Yet the films made on location in Arizona encompass the entire span of possible genres. The body of the state's filmmaking history is moving, memorable and truly magnificent. Although by no means an exhaustive portrait of Arizona's vast film and television history, the following chapters will introduce you to the state's influential and significant films that represent historic and contemporary eras of filmmaking in Arizona.

ACKNOWLEDGEMENTS

My deepest gratitude and appreciation go to the following organizations and individuals who assisted me tremendously in every aspect of writing this book:

Christine Aeurbach, Apacheland Movie Ranch, Arizona Film and Media Coalition, Arizona Historical Society, Arizona State Library, Arizona State Parks, Phil Bradstock, Veronica Burgess, Peter Catalonotte, Frances Causey, Timothy Flood, Emil Franzi, Jay Gammons, Shannon Gans, Shelli Hall, Jennifer L. Jenkins, Michael Kucharo, Marty Miller, Navajo Nation, Michael Ohrling, Old Tucson Studios, Oracle Historical Society, Jeffery Patterson, Phoenix Convention and Visitors Bureau, Phoenix Film Office, Pima County Library, Pinal County Historical Society, Prescott Film Office, Quartsite Historical Society, Philip Rauso, Sedona Chamber of Commerce, Sedona Film Office, Sedona Historical Society, Sharlot Hall Museum, Bob Sharp, Lisa Sharp, Bob Shelton, Yvonne Taylor, Marshall Trimble, Tubac Historical Society, Tucson Film Office, Tucson Historic Preservation Foundation, Visit Prescott, Visit Tucson, Victoria Westover, Tony Whitman, Jack Young, Yuma Convention and Visitors Bureau and Yuma Film Office.

A special thank-you goes to my fiancé, Theodore Manno, for all his support.

INTRODUCTION

WE'RE NOT IN CALIFORNIA ANYMORE

When I don't feel in the mood for painting I go to the movies for a week or more.
—Edward Hopper

S ince the nineteenth century, thousands of films, television movies and shows have been made in the state of Arizona, an incredible contribution to world film history. The state's cities, small towns and countryside have been the settings for countless westerns, comedies, dramas, action adventures, love stories and science fiction films, to name a few genres, and have all been featured on the big and small screens. Long before Hollywood was established, filmmaking in the state began as early as 1898. With the availability of moving image cameras and long-distance railroad travel, Arizona's incomparable scenery and Native American culture began to attract filmmaking pioneers eager to capture this vast, unexplored visual frontier. "Pathé sent cameramen around the world to capture actuality films," explained Jennifer L. Jenkins, film historian at the University of Arizona, of the French film production company. "Their device, the cinématographe, could both shoot and project, so they could offer programs of same-day local footage as well as scenes from other, exotic places." It was during these early filmmaking years that cinématographe screenings were reported in the Arizona Territory's mining camps.

With the expansion of the Southern Pacific Railroad in the early twentieth century, itinerant filmmaking crews such as the Philadelphia-based Lubin company began to travel by railroad around the country. It

was an exhilarating time in the film world on the brink of talking pictures that would change the movie experience forever. It was during this era that legendary director Cecil B. DeMille arrived in Prescott, Arizona, to begin filming a western, *The Squaw Man*. A blizzard sabotaged his plans, so DeMille's entourage continued farther west to a Los Angeles suburb then called Hollywoodland.

Although Arizona was passed over by the legendary director for the area that would eventually become Hollywood, its place in world film history would soon be firmly established. Through its locations, including Old Tucson Studios, as well as its natural and cultural resources, the state's film community would become a significant force in the history of film to rival even California. Arizona has been considered an almost ideal place for filmmaking for its beautiful climate and diverse settings of every human and natural environment imaginable. From Sonoran desert to mountains, lakes, forests, grasslands, ranches, farms, natural geologic wonders, sand dunes, dense urban areas, highways, dirt roads and roadside attractions, the scenery of the state's public and private lands has been immortalized time and time again for moviegoers. The rich iconography of western filmmaking owes much to the incredible wonderland of the Southwest. From early silent films and talkies to the Technicolor extravaganzas to modern studio and independent films, this diversity has been utilized and showcased to perfection. Indeed, Arizona became a last resort for filmmakers seeking this unspoiled frontier scenery that could accurately reflect the West at the turn of the century. The most famous example is the Rodgers and Hammerstein classic *Oklahoma!*, which used Arizona's cornfields and grasslands to represent the pristine, pre-modernized Oklahoma of the early 1900s.

The diversity of terrain and sheer number of settings are used to substitute for nearly every location that may be called for in a script, and this pays off in reduced production costs for film companies, increasing the overall appeal of filmmaking in Arizona. The state's largest cities, Phoenix and Tucson, have established film industries, with production companies, experienced actors and crews available to work on myriad film and television projects. "The industry is using our proximity to Los Angeles more and more strategically. Crews and executives like it because they can get here by air in an hour, work for a day, and be home for dinner," observed Dr. Jenkins. The benefits go both ways. The film industry has long had a reputation for being a clean business that costs the state little more than cooperation and requires no new infrastructure or financing. Since it is common for some film companies

to spend enormous sums of money a day in any given local economy, the returns that a rural community in particular receive are significant.

The culmination of nearly a half century of filmmaking, Arizona's Motion Picture and Development Office was created in 1971 to encourage movie and television filming in Arizona with the help of the Arizona Film Commission. As one of the first and most successful state film offices in the country, the office served as the liaison between production companies, government offices and the community. By the late 1970s, Arizona had become a powerhouse of filmmaking, ranking third behind Los Angeles and New York as a favorite for moviemakers. Then, in the 1990s, on the heels of the mega-hit modern western *Dances with Wolves*, Arizona reported record-breaking profits that spread throughout the state from production of movies, commercials and industrial films. In terms of big-budget productions and taste, the focus shifted from westerns to sci-fi and action films, such as the *Star Wars* trilogy, *Three Kings* and *The Postman.*

In recent years, the existence (or not) of film incentives has played a critical role in encouraging filmmaking around the world. After Canada began to offer incentives to the film industry in the 1990s, followed by Louisiana and New Mexico, Arizona also implemented its own version in 2005, a transferrable tax credit. As part of the state's cost-cutting efforts during the recession, the film office was officially closed in 2011 after the motion picture tax incentive expired at the end of 2010. The incentive had attracted many films, such as *Everything Must Go* with Will Ferrell. "Now Arizona is taken off the table as far as filming goes," said Phil Bradstock, manager of the Phoenix Film Office. "There have been numerous projects that have been dropped when the incentive phased out. Traditionally, Arizona is not an incentivizing state; mainly local people advocating for filmmaking to happen."

Once one of the biggest players in the movie location business, Arizona is now completely off the grid. The state continues to lack an industry-specific incentive, as well as a state film office, making it the only state in the Southwest lacking the necessary resources to attract large projects. "In the old days, there was no tax credit anywhere, so it was pretty much a level playing field," explained Eric Hofstetter, a former Phoenix-based locations scout and production manager. "You would shoot at a location based on its merit, and our merit was sunshine."

"The Arizona Film and Media Coalition [AFMC] is currently working on getting this extraordinarily important office reopened," said Mike Kucharo, president of AFMC, with an eye on running new incentive legislation.

Since its earliest years, Arizona's filmmaking community has undergone rapid changes in culture, technology and economic conditions, with one key feature remaining constant: the scenic majesty of the state. Successful modern studio and independent films shot on location around the state, including *Raising Arizona*, *Jerry Maguire* and *Jolene*, among many others, demonstrate that modern-day movies can be done here with great success. Old Tucson Studios recently welcomed the making of *Hot Bath an' a Stiff Drink*, a western for the new millennium, as well as its sequel, despite the lack of any film incentive. Perhaps it is a sign of a resurgence of movies shot on location in Arizona and a new golden age of filmmaking. The best may be yet to come.

CHAPTER 1
THE WESTERN AND BEYOND

Celebrating the Southwest's Frontier

My friends just call me Ringo.

—*John Wayne*, Stagecoach

Without a doubt, the most significant film genre to Arizona's statewide culture and identity is the western. Hundreds of made-in-Arizona westerns—including *Stagecoach*, *The Searchers*, *Red River* and *How the West Was Won*—reenact or retell real historical events using the locations and settings where those events actually occurred. However, the earliest films that can be classified as westerns were made by the Edison Company in New Jersey's pine forests. The year 1903's *The Great Train Robbery*, a dazzling ten-minute-long silent film, is the world's first western, with a quintessentially western ingredient: the hero played by pioneering movie cowboy Max Aronson, later known as "Bronco Billy." From these first primitive films produced in the suburbs of New York, Philadelphia, New Jersey and Chicago, westerns soon journeyed west. The region's year-round mild climate, coupled with lower production costs and the vast amount of beautiful scenery available at no cost for filmmaking, all catapulted the ultimate decision by many filmmakers to make westerns in their true settings.

Aronson partnered with George K. Spoor, the proprietor of the Kinodrome Circuit, which showed motion pictures in the Orpheum vaudeville theaters of the West; organized the Essanay Film Company (a phonetic combination of their initials, *S* and *A*); and began producing one one-reel cowboy adventure after another in California and Colorado initially. Other momentous

happenings include Selig Polyscope Company's release of *Ranch Lombstoneife in the Great Southwest* in 1910, with its newly discovered star Tom Mix. These new westerns filmed in the Southwest became wildly popular, particularly in Europe. Bronco Billy made close to four hundred one-reelers that captured the public's imagination. Then William S. Hart, or "Rio Jim," came on the scene.

Unlike Aronson, Hart was from the West. Hart grew up on the Dakota prairies and could even speak Sioux. As a young man, he worked his way up as an actor on the New York stage and then toured the country in road shows. After viewing the westerns being presented at the time, Hart became keenly interested in making movies based on his own personal knowledge of the West. Hart convinced an old friend, Thomas H. Ince, then manager of the New York Motion Picture Company, of the possibilities of using realistic material to compete with the inauthentic westerns flooding the country. One of the early movie cowboys, Hart's first feature film, *The Bargain*, was shot on location at the Grand Canyon in 1914. It was Hart who created the character of the "Good Bad Man," the glorified outlaw. Hart's films often had tragic endings, contrasting sharply with many westerns.

With the closing of World War I, though, audiences craved illusion, not reality. More of an artist, Rio Jim refused to appear in any film not up to his realistic standards, famously stating that "the truth of the West mattered more to me than a job," and the era's movie moguls inevitably catered to popular tastes. Western movies after this time reflected a more stylized Hollywood version of the West, with glamorous, handsome "King of the Cowboys" Tom Mix as its idol-elect.

Since their beginnings, westerns would fall in and out of favor with American audiences; time and again, the western would be pronounced a thing of the past. There is no other type of film, however, that has so seized the imagination of the world. Emil Franzi of the Empire Ranch Foundation pointed out that "Wyatt Earp has been continuously in publication since 1931. For everybody who read it, ten others have seen *Tombstone*...What made the classic westerns so entertaining was the deep cast of character actors who backed up the stars. Cumulatively, folks like Walter Brennan, Edgar Buchanan, Jack Elam, Ben Johnson and Slim Pickens, plus a hundred more, gave westerns an incredible depth. The western movie female was a genuine and multifaceted babe who was just as tough as some of the current feminist caricatures," said Franzi.

The western offered an escape from the constraints and realities of modern living and evoked for audiences a primitive struggle to survive largely absent today through accurate reflections of real life out west. The popularity of

westerns also lies in the genre's reflection of the country's changing economic system. The western film plays on a subconscious desire for a simpler existence, removed from technology, development and population pressures. Native American audiences responded to the fantasy of freedom, independence and the familiarity of the settings represented in the western. Anglo audiences viewed the western as a story about their ancestors, and audiences generally identified with the good guys in the film, whatever their ethnicity.

The western plot comes down to a few simple characters: a hero, a villain, a virtuous woman and a good-bad woman packaged in different settings with endless concoctions of storylines. The hero always wins, and the bad guy is ousted or outmatched. Westerns are "melodrama out in the sagebrush," commented Larry Walther, a locations manager in Phoenix. "The good guys wear white; the bad guys black." The landscape of the American West is the backdrop for relatable human conflicts—power struggles and the fight against a corrupt world. Although formulaic, the formula proved to be a sure thing.

The genre's contribution to cinema cannot be underestimated. Early "flickers" were simply stage plays with the camera in a fixed position viewing the entire action; early westerns, in contrast, gave the movies a new spaciousness and freedom of movement against thrilling backdrops, influencing the development of modern outdoor cinematography. Before the coming of talking pictures in the early 1920s, action was the primary vehicle for storytelling. "Tempo and rhythm were pioneered and developed in these early westerns, helping to perfect a cutting technique that has since been utilized in everything from action pictures to gangster films and to war movies," said Jennifer Jenkins.

With one hundred or more of these similar types of pictures coming from the studios each year, the novelty of the genre soon wore thin, and by the early 1920s, westerns had lost their momentum at the box office. Sound influenced a temporary setback for the genre with its emphasis on talk and music rather than action. Recording sound on an indoor stage was problematic enough, and experts claimed that it could not be done outdoors. But in 1928, Fox Studios proved them wrong in presenting *In Old Arizona*, the first all-talkie outdoor film with Warner Baxter as the "Cisco Kid."

Westerns did not become popular items of the major studios, however, until 1931, when Universal brought Tom Mix back to the screen. Other "Singing Cowboy" stars like John Maynard, Gene Autry and even John Wayne obliterated the grim realities of the Depression for audiences during the talkie era. These are the films that make up the bulk of westerns made in this country.

THE WESTERN IN ARIZONA

With other studio achievements such as *Gone with the Wind* and *The Wizard of Oz*, the year 1939 would become a pivotal one in the history of filmmaking in Arizona. Gary Cooper made *The Westerner*, based on a famous novel by Zane Grey, in nearby Green Valley and also starring Walter Brennan and Doris Davenport. Errol Flynn also filmed scenes from his latest, *Dodge City*, that year, and the monumental achievement of John Ford's *Stagecoach* was filmed on location in Arizona's Monument Valley.

Before World War II, with already well-established locations and business relationships, California had been turning out westerns by the hundreds. Through selling the films to the foreign markets, there had been a sure return on investment. With war looming, the movie industry adjusted by appealing to American audiences with new and greater authenticity in western locations. In the 1940s, there was an intense migration of filmmaking from Hollywood to Arizona. Sedona, Prescott and Tucson became prime locations for western filmmaking, although they often doubled for other parts of the country.

Samuel Goldwyn Inc. was one of the early movie companies to select Arizona as the location in which to make *The Westerner*. In Arizona, moviemakers found to their delight more cooperation from locals than in California, as extra charges sought by owners of locations that the movie industry desired did not yet exist. There were other, more aesthetic reasons for making movies, and particularly westerns, in Arizona, including the spectacular light and cloud effects. Nick Hall, the manager of Tucson's Santa Rita Hotel, was largely responsible for selling Tucson to the movie industry with the idea that the movie crowd would become hotel regulars— and they did. Hall enticed Hollywood with so many clouds that the Goldwyn studio created a picture with Hall riding a bicycle track of billowy clouds to hang in the hotel's lobby. The creation of Old Tucson Studios during the making of the film *Arizona* in the early 1940s initiated the state's golden age of filmmaking, which continued over the next four decades.

The state has historically been one of the first places considered by filmmakers for such projects, and with films such as *Stagecoach*, *Red River* and *Tombstone*, Arizona over the years had become synonymous with the western. "These films were pioneers of the genre. All of us learned from that what was made before us," said Bob Shelton, former CEO of Old Tucson Studios. The major studios in the state that churned out westerns included

Old Tucson Studios, Mescal, Apacheland Movie Ranch, Cowtown, Carefree Studios, Rawhide and C.J.S. Film Studios, many of which have gone boom and bust since the mid-twentieth century.

Reinvention and Renewal: The Future of a Genre

After dominating film and, later, television for years, the western seemed to disappear in the 1970s and 1980s. The western became out of step with most Americans due to its unsympathetic and, in many cases, racist depictions of Native Americans, Latinos and African Americans, rendering the genre outdated and unsustainable. Most of the big- and small-screen westerns since the mid-1980s have attempted to redress these antiquated racial and ethnic caricatures. In addition, there has been a renaissance of filmmaking highlighting a more realistic Native American experience throughout the United States.

Notable award-winning Native American filmmaker Chris Eyre, an alumnus of the University of Arizona, directed *Smoke Signals*, with its non-stereotypical portrayal of Native Americas. "I'm not against western films; it was probably the first time Native American culture became part of pop culture," commented Apache art curator, writer, producer and local documentary filmmaker Douglas Miles. Miles's films, just by their very existence, push back against Native American stereotypes in film. Miles spent his formative years in Phoenix and San Carlos, Arizona, and has produced films with Apache Skateboards for almost ten years, creating short, authentic films highlighting Native American youth culture.

Westerns enjoyed a resurrection in popularity during the 1990s with the genre's ability to strike a nostalgic chord with the baby boom generation that grew up with such television shows as *The Lone Ranger*, common fare at Saturday movie matinees and in dime novels. From its beginnings, the western has been reinvented anew time and again, in part because in every decade, a film appears that reignites the public's enthusiasm, connection to and interest in the genre. Clint Eastwood's *Pale Rider* and *Unforgiven* and Kevin Costner's *Dances with Wolves* are modern-day examples of this simple truth. "Westerns, even the mediocre ones, are fun for even today's audiences. Interest in history is evidenced by the History Channel's expansion to multiple versions," added Franzi.

Although the western as a genre may have been pronounced dead, archaic or irrelevant, westerns never leave the minds of filmmakers entirely. Today, scores of filmmakers are producing and reinventing western filmmaking for new generations of audiences. In 2013, Tucson saw the screening of a new hit western, *Hot Bath an' a Stiff Drink*, at the Fox Tucson Theatre; it was filmed on location across southern Arizona. Jay Gammons, owner of Gammons Gulch Movie Set and Museum, related his experiences at the premiere when lead actor William Shockley said to the sheriff and deputy, "There's a sand storm coming." They, in turn, say, "We don't see any sandstorm," and Shockley responds, "Custer didn't see any Indians either." Everyone in the theater laughed, Gammons remembers. Audience connection is an omen of much to come.

"ARIZONA MOVIES"
By Michael Van Walleghen

1

Rosetta, her new boyfriend
and all four kids
are going to the drive-in
down in San Manuel.

"One more beer," they tell the kids
"and then we'll go."
The kids
want a quarter a nickel
another dime—the kids

are a pain in the ass
the movie is about a dog
and the boyfriend wears glasses
baggy double-knit slacks

and a white belt. Rosetta,
on the other hand, is beautiful,
elegant, altogether sweet
in her new blue sweater

and when she reaches in her purse
to buy another round,
I spot her little silver gun.
"That's just in case," she says,

"just in case."

2

Sometimes even
in the middle
of the year's best movie
you can hear coyotes
at the San Manuel Drive-In.

Tonight, they are far away
and merely barking at the moon...

but Rosetta tells me
that when they chorus close
and suddenly together

hysterical, high pitched, furious

it means something is dying
in the dark foothills
behind the shaky screen.

3

After the bad movie
Rosetta wants to finish off
what's left of the tequila
drop off the kids

and then go dancing…!

But I don't know about Fred.
I think Fred sells mobile homes—
convenient, air conditioned,
catastrophically fragile,

I pass them everyday
and try to imagine myself
living there: the tv on
all the kids at school

and Rosetta, just lying
on the couch, just watching,
through the picture window,
some Apache ghost dance
cavalry of thunderheads
advancing slowly out
from between Mount Lemmon

and a pigeon blue wing
of the Catalinas.

4

No one is dancing
up at Pop-A-Tops. No one
is speaking. The tv's on
and in the Merry Christmas

snow flaked mirror, Fred
is shooting pool. Rosetta,
on the other hand, shreds
her matches into tiny bits

then looking up, her look
slides sidelong into mine—
the tense, unsteady look
I think, of children

getting lost…but what
was it that I thought to say?
Something dumb, mindless
a remark about the movie

or at my best, to notice
on that long, small arm
her careful, bar-room bracelet
of pink and yellow straws.

Whatever it was, she answers
to the whole place—loud,
and before I say a word: "Nope,
I'm not dead yet"

and the fuzzed up mirror
keeps still, stays quiet
as the slow blue echo of a pistol shot.

5

Rosetta says she's 32
but Fred looks younger.
Fred's even younger partner
works the graveyard shift

at Magma Copper
and behind us all
the Falstaff clock turns counter
clockwise

towards eleven. "One more game,"
they tell Rosetta, "and then
we'll go." The Lariat?
The Hangman's Tree?

"Why not Rosetta's place?"
Fred's partner whispers.
A joke perhaps. But still
it's curious, frightening

that I should also hear
in the shy nylon whisper
of Rosetta's thighs
in the click of small ice

something dangerous, random,
confused as kitchens,
cupboards where the knives
are kept, bedrooms

in the Apache Trailer Court
with real bullet holes
above the door.

Like Rosetta
I too hear voices.

Tonight, they are speaking
the frazzled language

of neon, the cindered
impossible language

of parking lots, static
and revolving lights…

but sometimes, it's Rosetta—
her voice still angry

clear, above the voices
of the graveyard shift

who slam their doors
like Fred or anyone

going off half drunk
to work tonight

in knee deep water
and the hot acidic dark

one full mile
underground.

Reprinted by permission
from the *Hudson Review 29, no. 3*
(Autumn 1976).

CHAPTER 2
TUCSON

Classic Country

Tucson is where, by golly, you can really feel and live like a normal human being.
—*William Holden*

Moviemakers have long made use of southern Arizona's landscape, light and a climate that allows for continuous open-air shooting, including with the American Film Manufacturing Company's *The Mission in the Desert* in 1911. In 1912, Arizona achieved statehood, along with genuine movie location status a mere five years after the establishment of Hollywood. Since that momentous year, the city of Tucson has promoted the area's many charms to establish and maintain a permanent motion picture industry in the region.

LUBIN MANUFACTURING COMPANY

In March 1912, twenty members of the Western Lubin stock company arrived in Tucson from the east. It was a subsidiary of Philadelphia's Lubin Manufacturing Company, founded by Siegmund Lubin, that grew from 1895 to 1916 to be one of the largest motion picture production companies in the world. Lubin's moviemaking empire began with the purchase of one film projector in 1895. Before long, it included a chain of movie theaters, multiple

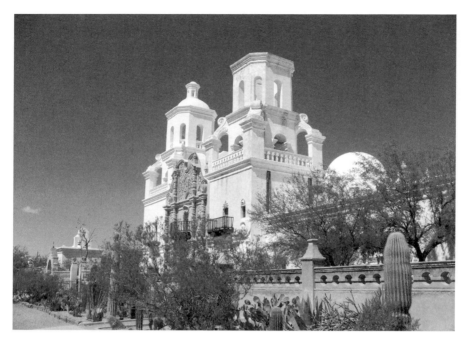

The Lubin company utilized San Xavier del Bac Mission as a filmmaking location in Arizona's early days of statehood. *Author's collection.*

state-of-the-art production studios across the United States, hundreds of employees, numerous patents for recording and projecting equipment and international movie distribution. The company had been gradually filming its way west, stopping in El Paso for five weeks before reaching Arizona. With an operation set up at a private residence on North Stone Avenue in Tucson, Lubin released the following year a short documentary called *San Xavier Mission, Tucson Arizona.* The company's film *Renunciation* also utilized San Xavier del Bac Mission as a location in 1914. Over time, Lubin made a total of eight movies, mainly one-reel westerns in Tucson starring the charismatic writer-producer-actor-director Romaine Fielding. "If I want to get pictures of the old town in its famous frontier days, all I have to do is go down on Meyer Street," Fielding told the *Arizona Daily Star* in 1912.

Fielding was the most popular film actor in the country at the time and one of the first filmmakers to shoot westerns extensively on location throughout the American Southwest during an era when westerns had been largely shot in the Eastern United States; this changed filmmaking forever. Fielding's films were profound explorations of the effects of the West's landscapes on

the human psyche. Both audiences and critics celebrated his unique work. "His dramas are not only thrilling representations of western life, but they go to the very heart of things; the atmosphere of lives spent in the vast expanses of the world. He understands the real difference between the west and the east," noted the *Silver City Independent* in 1913. Fielding defied widespread conventions by presenting Hispanic characters not as bandits but as heroes. Although he is largely forgotten, Fielding was undoubtedly an influence on William S. Hart and countless other filmmakers.

Fielding received city cooperation by touting the publicity that the films could generate—publicity that would make people come west. "Tucson was the epicenter of early filmmaking, and it was a real boom to the economy," said Demion Clinco, president of Tucson Historic Preservation Foundation. The gold rush–themed *Sleeper* became the company's biggest and most successful film and also the last the Lubin company would make in the Tucson area. The film's climactic scene was filmed at the base of Sentinel Peak ("A" Mountain). Soon Lubin was lured away from Tucson by the Prescott Chamber of Commerce in 1912. Tucson never saw Fielding or the Lubin company again, but the company departed having contributed more than $6,000 to the local economy, a small fortune at the time.

ÉCLAIR FILM COMPANY

The following year, the New York City–based, French-backed Éclair Film Company arrived in Tucson. Perhaps attracted by one of the earlier Lubin films, the Éclair company had come to make *The Caballero's Way*. Directed by William Cullison, the film was based on a story by O. Henry featuring the Cisco Kid. O. Henry was the pen name of William Sidney Porter; his Cisco Kid was neither Mexican nor heroic but rather a cold and ruthless Caucasian. Herbert Stanley Dunn became the first to portray this legendary character on film, although the Cisco Kid as we think of him today, a charming Mexican adventurer, originated from Warner Baxter's portrayal in the 1929 film *In Old Arizona*, nominated for a Best Picture Oscar in only the second year the Academy Awards were presented. Filmed behind the torn-down Santa Rita hotel that once served as a home away from home for countless movie companies, the response to *The Caballero's Way* was so positive that Éclair established a permanent headquarters in Tucson at

430 Main Avenue. The majority of Éclair's films were one reel in length, written and starring Herbert Stanley Dunn as the Cisco Kid; they became the first motion picture series. The company made about eighty films in nine months. Some of the most important movies were *Picturesque Tucson*, *The Stirrup Brother*, *When Death Rode the Engine* and *The Renunciation*. All were shot in the Greater Tucson area at signature locations such as South Meyer Avenue, San Xavier del Bac Mission, the Tohono O'odham reservation, Sabino Canyon and Saguaro National Park.

The Cisco Kid films continued with great success well into 1915. Then war broke out. With Éclair's parent company and financial backing based in France, the company's capital was redirected to support France's war effort, and the New York offices were disbanded. In Tucson, the Éclair company members decided to seek new financial support in Hollywood, but sadly, the company soon faded into obscurity. The company's parting gift to the City of Tucson before leaving for Los Angeles was a set of street signs for automobiles reading, "Turn to the Right—Cross Before Turning."

CUAUHTÉMOC FILM MANUFACTURING COMPANY

At about the same time, Tucson became a mecca for Mexican artists, who fled their homeland after the Mexican Revolution. In August 1915, a group gathered at El Teatro Carmen to discuss the establishment of the Cuauhtémoc Film Manufacturing Company. The first shareholders in the company included Teatro Carmen's owner, Carmen Soto de Vázquez; Estevan R. Aros of Tucson's Teatro Royal; and Francisco Díaz López, manager of the Ramírez Theater in Nogales, Sonora.

The Cuauhtémoc company's offices and laboratory were first installed at the Mission Photography Studio on West Congress Street. This photo lab permitted the company to locally process films, creating the first film processing plant in Tucson. In addition to producing dramas and comedies, Cuauhtémoc filmed advertisements for local industries. The establishment of the Cuauhtémoc Film Manufacturing Company exemplifies the dynamism of Tucson's early Hispanic community, with its films capturing key aspects of Tucson and its vicinity in Arizona's early years of statehood.

In 1917, Douglas Fairbanks became the first true movie celebrity to film in southern Arizona, only two years before the formation of United

El Teatro Carmen

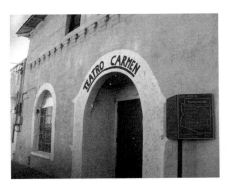

Early Spanish-language theater El Teatro Carmen in Tucson's historic Barrio District. *Author's collection.*

Located in Tucson's Barrio Viejo, one of Tucson's oldest and most beautiful historic neighborhoods, El Teatro Carmen is a gold-colored theater designed in the Sonoran mission style. The theater was opened by trailblazing businesswoman Carmen Soto de Vásquez, member of a prominent Tucson pioneering family. Opening night on May 20, 1915, featured *Cerebro y Corazon,* a play by the Mexican author and poet Teresa Farias de Isassi, and soon superb Spanish-language plays and literary productions, as well as operas, musicals and melodramas with troupes from Spain and Mexico, appeared. With a vibrant theater scene, Tucson became the center of culture in the Southwest during a time when music, operas and theatrical productions were the dominant form of entertainment in the country. El Teatro Carmen was geographically at the center of the city's cultural renaissance and was known as the most elegant theater of its era. Soon, though, movies and boxing matches began to encroach on the theater's audience.

In 1924, Carmen Soto de Vasquez moved to Nogales with her husband and family. The theater was sold in 1926. The building has been owned by the Rollings family for more than two decades. Since the 1970s, the Rollingses have been influential in the business of renovating historic adobe buildings in Barrio Viejo. They purchased Teatro Carmen with the intent to revive its association with live entertainment and to share its place in Tucson's history as one of the few surviving 1870s adobes in the city. A local group, Borderlands Theater, used Teatro Carmen as a venue for three seasons from 1987 until 1989. The theater's iconic façade has been shown in the films Boys on the Side and Goats. Sadly, structural damage inhibits the full restoration of this treasure.

The Light of the Western Stars (1925). *Courtesy of Arizona Historical Society, Buehman-Subjects-Motion Pictures.*

Artists by himself, Mary Pickford, D.W. Griffith and Charlie Chaplin. Fairbanks shot two films while in the area—the story of an Arizona railroad swindle called *Wild and Wooley* and *Headin' South* in Nogales. A year later, the beautifully titled *Light of the Western Stars*, starring Hollywood western star Dustin Farnum, filmed at Sasabe's Rancho de La Osa and other area ranches.

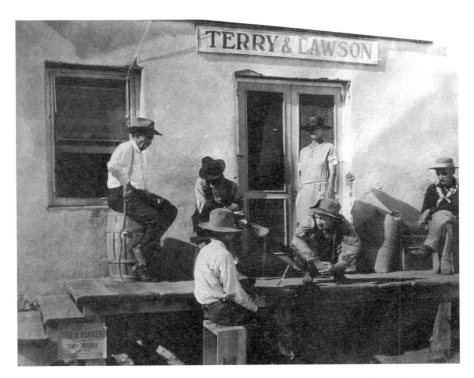

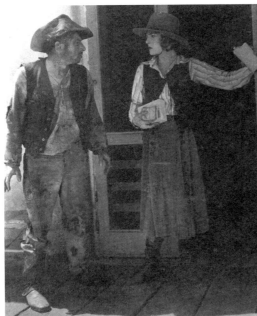

Above: The 1924 film *The Mine with the Iron Door* is said to be the first Hollywood film shot entirely on location. *Courtesy of Oracle Historical Society.*

Left: *The Mine with the Iron Door* filming at Oracle's post office. *Courtesy of Oracle Historical Society.*

The 1924 film version of Harold Bell Wright's famous novel *The Mine with the Iron Door*, with Pat O'Malley, Dorothy McKaill, Charlie Murray and other silent film greats, was shot on the north side of the Catalina Mountains, around Oro Valley in the small town of Oracle's post office and Rancho Linda Vista. The film's director, Sam Wood, later partially directed *Gone with the Wind* and became a figure in the McCarthy Hollywood trials. At Linda Vista, cottages were built to house the movie people. Ranch owner George Wilson wrote:

> *The guests at the ranch and me got a big kick out of watching them make this movie. No one had ever seen anything like it before. I remember one day that a laborer while digging a hole for a post near the creek found a gold nugget about the size of a large pea. He showed this around and for two days there was no work done on the movie as everyone on the set, including actresses, was hunting for nuggets. No other ones were found so the boom was over. The movies are very extravagant, at least this company was. The set where they were making the picture was three miles across the hills from the ranch and about eight miles by road around the hills. Every night they made out their orders and I was ordered to have thirty saddle horses on the set by 7'oclock the next morning. Later they had a preview of the picture in Tucson and we all went in to see it.*

THE TALKIES COME TO TUCSON

It's such a wonderful night…moonlight and desert…anything can happen on a night like this.

—*Ida Lupino*, The Gay Desperado

Tucson's first motion picture world premiere was Warner Baxter's pioneering talkie *In Old Arizona*. Filmed in Arizona's Santa Cruz County, the movie was "one of the greatest ever filmed," noted one reviewer. Baxter returned to star in *The Cisco Kid*, the sequel to the film shot in the Catalina Mountains. Two years later, blonde bombshell Jean Harlow played the title role in the aptly named comedy-drama-satire *Bombshell*, directed by *Gone with the Wind*'s Victor Fleming. Harlow breezes through the film's guest ranches and cactus garden scenes around Tucson on location, and "the world thrilled to the

The 1936 musical comedy *The Gay Desperado* shooting in Tucson's Barrio Viejo. *Courtesy of Arizona Historical Society, Motion Picture Photograph Collection.*

sight of one of the screen's loveliest ladies," noted one newspaper account of the film. As a publicity stunt for the film, Harlow was named a deputy sheriff of Pima County.

Tucson's Screen Triumph

In 1936, United Artists produced *The Gay Desperado*, which depicted border bandits who try to learn lessons from American movie gangsters; it was shot at many of the Tucson area's most famous sights: San Xavier del Bac Mission, Tumacacori Mission, Saguaro National Monument, the Rialto Theatre and in Barrio Viejo. Directed by Rouben Mamoulian, the film starred Leo Carillo and English actress Ida Lupino in her first American

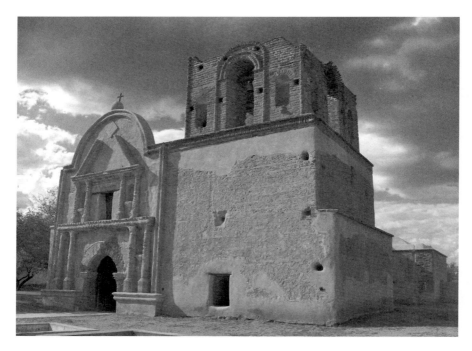

The Gay Desperado was filmed at some of Tucson's most celebrated sights, including Tumacacori Mission. *Author's collection.*

picture. Carillo reportedly stole the show from Metropolitan Opera star Nino Martini, despite his beautiful voice. "It is good entertainment—boisterous and absurd," wrote the *Arizona Daily Star* in 1936. Years later, Carillo would play the role of Pancho in television's *Cisco Kid*, and Lupino became an accomplished motion picture and television director in her own right. Mamoulian would win the Oscar for Best Director of the year.

The world premiere of *The Gay Desperado* was held at the Fox Tucson Theatre, its first in more than ten years. Long lines of disappointed people were turned away from a packed auditorium, while Tucsonans who took part in the film walked across the stage. One review commented, "When not concerned with the wonderful voice of Martini or the delightfully absurd lines of Carillo, the audience was awestruck at the magnificence of Tucson's scenery—the mission of San Xavier del Bac, the cactus forest [Saguaro National Park], night and sunrise cloud effects, Meyer or Convent street scenes."

Fox Tucson Theatre: The Evolution of Entertainment

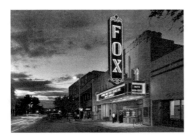

The southwest deco Fox Tucson Theatre is a performing arts center that shows classic films and musical acts with national and international reputations. *Courtesy of Fox Tucson Theatre.*

In 1929, construction began on what was to be called the Fox Tucson Theatre in downtown Tucson. The most lavish theater in the state, on opening night on April 11, 1930, Congress Street was closed for a massive celebration, with dancing, live bands and a live radio broadcast. Three thousand people were in attendance at the event, which featured the MovieTone short Chasing Rainbows and a Mickey Mouse cartoon. For the next forty years, the Fox Theatre served as the preeminent institution of the city's entertainment world. "Historically, we were a classic movie house," said Craig Sumberg, executive director of the Fox Theatre Foundation. The disappearance of retail and housing in downtown Tucson brought the end to the theater in 1974. Fortunately, the property was spared complete destruction and today enjoys a kind of new lease on life as more of a performing arts center showing classic films, lectures series and musical acts.

With its spacious indoor facilities and acoustic features, "if you are talking about a high-end performing arts theater, there's nothing like the Fox," added Sumberg. One of the few theaters left in this country with beautiful German reel-to-reel projectors, the benefit for the public is that you can still watch classic films as they were meant to be seen. Many Tucsonans have vivid memories of coming to the theater to see weekly installments of the Mickey Mouse Club before it was televised. John Wayne would even come into the theater when he came to town making films. When the Fox shows John Wayne films now, theater staff members claim to sense Wayne's ghost hovering nearby. The theater reopened to the public in 2006. Downtown Tucson is undergoing revitalization at the moment, with new restaurants and streetcars. "The reality and perception of downtown is changing very rapidly, and that bodes well for the Fox Theatre. The goal of the Fox Theatre Foundation is to create the most successful performing arts center in the Southwest." Contact: 17 West Congress Street, Tucson, AZ, 85701, (520) 624-1515, www.foxtheatre.org.

Old Tucson Studios: A Filmmaking Renaissance

We're not north, we're not south...we're the West—and we build what we have out of desert and mountain.

—*Jean Arthur,* Arizona

In 1939, filmmaking in southern Arizona really exploded with the construction of Old Tucson Studios, built for *Arizona*, Columbia Picture's epic story of Tucson in the 1850s. Five years before this milestone event, an individual who would shape the scene of southern Arizona filmmaking for the next decade arrived in Tucson: Nick Hall, manager of the Santa Rita Hotel in downtown Tucson. Hall observed that development of the area's movie business would be beneficial not only to the town but to his hotel as well. Upon learning that Columbia Pictures had acquired the film rights to *Arizona*, a historical novel by Clarence Buddington Kelland, Hall began aggressively lobbying studio executives to make the film in Tucson. His efforts were successful, and in July 1939, Columbia began its massive construction of an authentic replica of pre–Civil War Tucson for the filming of the black-and-white outdoor epic.

Originally conceived in Technicolor, the Wesley Ruggles production was downscaled to black-and-white during the war years. The story of "tempestuous love and the drama of a tumultuous era," *Arizona* stars Jean Arthur as pioneer Phoebe Titus, who operates a freighting business and falls for then unknown William Holden. One of the few westerns with a strong female lead, Arthur's character is a kind of Wild West Scarlett O'Hara. Arthur would go on to star in the Oscar-winning western *Shane*, widely regarded as one of the top westerns of all time. Holden would later win an Oscar for *Stalag 17*.

The film premiered at the Temple of Music and Art and four other theaters in Tucson, with the film's glamorous stars making appearances at each showing. The festivities of the premiere included a horse-drawn parade and a midnight feast with three thousand revelers. "It takes a very melancholy pessimist to depreciate the conviction that this city is already established as an important factor in the cinema world," noted the *Arizona Daily Star* in 1942. Although the film never achieved classic film status, it contributed much to Tucson's film history and culture; investment in the natural environment of southern Arizona soon began to pour in, and Tucson was established as "Hollywood East."

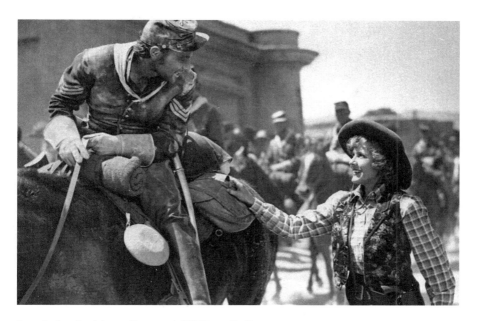

Jean Arthur in *Arizona. Courtesy of Old Tucson Studios.*

With cornerstone film *Arizona*, Old Tucson Studios had its kick-start, and the city and region gained permanent movie momentum. From 1941 to 1945, notable films that were made at Old Tucson Studios included *The Bells of St. Mary's*, starring Bing Crosby and Ingrid Bergman, which filmed its church scene at the studio, and the David O. Selznick epic *Duel in the Sun*, one of the highest-grossing westerns of all time, which filmed at Tucson Mountain Park among many locations around southern Arizona. Then, from 1947 to 1951, the classic *Winchester '73* with James Stewart, the biblical epic *David and Bathsheba* and future president Ronald Reagan's western *The Last Outpost* further solidified the state as a movie capital.

The 1950s brought an even greater uptick in filmmaking at Old Tucson, mostly westerns, with the exception of Disney's *Living Desert*. Then, in the 1960s, successful Kansas City country club developer Bob Shelton leased the rights to develop and run Old Tucson as an amusement park and movie location. Shelton developed into the most productive promoter for filmmaking in the state. Under his auspices, Old Tucson Studios became one of the most visited tourist attractions in the state. "We were associated with over three hundred films during my tenure as founder, president and CEO," said Shelton, who explained that Old Tucson Studios can be seen in

Mescal

Located in the high desert of Cochise County, southern Arizona's western movie town, the Mescal set, is just off Interstate 10. While Old Tucson is surrounded by mountains and Sonoran desert, Mescal's terrain resembles a western prairie, with its green rolling hills and tall grasses, giving movie producers a very different historical and aesthetic look for their productions. Mescal was purchased by Old Tucson Studios from CBS in 1968 after the network completed filming Monte Walsh *with Lee Marvin, a film dealing with the disappearing lifestyle of the cowboy. Originally named Happy Valley, the area was renamed when* The Life and Times of Judge Roy Bean *with Paul Newman came to film.*

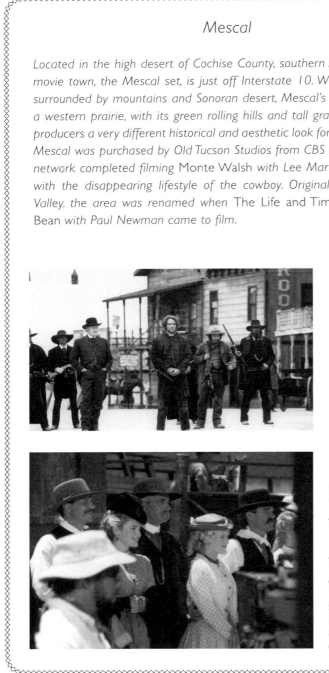

Top: Scene from *The Quick and the Dead. Courtesy of Old Tucson Studios.*

Bottom: The 1993 remake of classic western *Tombstone* was filmed at Mescal, Babacomari Ranch and Eglin. *Courtesy of Old Tucson Studios.*

the context of a larger trend of moviemaking in the state, with a "history of good working relations and conditions that goes back to the beginning of the early one-reel silent days of 1911."

With Old Tucson's new dual role as a theme park and movie location, the 1960s became the renaissance decade of filmmaking in Arizona—a highly productive decade with numerous Oscar-winning actors and actresses filming at the studio, including Frank Sinatra, Elizabeth Taylor, Paul Newman, Audrey Hepburn, Ingrid Bergman, John Wayne, Jimmy Stewart, Burt Lancaster, Kirk Douglas, Lee Marvin, Dennis Hopper, Clint Eastwood and Robert Duvall. Acclaimed 1963 film *Lilies of the Field* starred Sidney Poitier as a handyman drifter helping a group of nuns build a chapel at their convent in the desert. Shot in fifteen days, much of *Lilies* was filmed at an abandoned house along the Tanque Verde Wash in Tucson. The chapel in the film was built near the intersection of Sabino Canyon and Tanque Verde Roads.

In 1968, pop artist and filmmaker Andy Warhol once produced an avant-garde *Romeo and Juliet* film at Old Tucson Studios. With Warhol's reputation for eccentricity, the movie was predicted to be unlike any other previous version of Shakespeare's tale of star-crossed lovers. No one was aware until the first day of shooting, however, that Warhol's version would feature a nude cast on motorcycles. "I stopped him from filming naked actors at our facilities in Old Tucson, which of course did not sit well with him. Our tourists from out of state started arriving to visit as early as 8:00 a.m., and I could not expose them to a town full of naked cowboys and cowgirls," commented Shelton. The cast was promptly corralled away from visitor areas. Then, after an additional inappropriate situation during the filming of the strange and captivating erotic film *Lonesome Cowboys* that same year, Andy Warhol was asked to leave Old Tucson. *Lonesome Cowboys* was subsequently shot in tiny Oracle as an alternative. Could this controversial film have influenced *Brokeback Mountain*, the Annie Proulx short story published in 1997 and later adapted to film? One cannot help but wonder.

The prolific 1970s brought stars such as Burt Reynolds, Clint Eastwood, Robert Duvall, Paul Newman, Kirk Douglas, Burt Lancaster, Barbra Streisand, James Caan, Steve McQueen, Gene Wilder and others as prominent and frequent participants in numerous local productions, with colorful behind-the-scenes stories and hijinks. During the shooting of *Rio Lobo*, the Academy Awards were announced, with iconic actor John Wayne getting the nod (for *True Grit*). "They shot around him while he was back receiving his award. However, when he returned and walked onto the set everyone had an eye patch, even the horses had an eye patch and they

John Wayne in *Rio Lobo. Courtesy of Old Tucson Studios.*

Kenny Rodgers filming *The Gambler* at Old Tucson Studios. *Courtesy of Arizona State Library, Archives and Public Records, History and Archives Division, Phoenix.*

had built a giant Oscar from plywood which also had an eye patch. It was the only time in all the movies I made with John Wayne that I watched him outwardly cry," remembered the film's stuntman, Jack Young. Many of Wayne's most famous roles, from *Stagecoach* to *Red River* and *Rio Lobo*, were shot in Arizona. Wayne even owned a ranch in Arizona's White Mountains. *Rio Lobo* also starred Jack Elam, best known for his villainous roles in many westerns.

During the 1971 filming of *The Life and Times of Judge Roy Bean*, Paul Newman, who played the corrupt judge in the film, had a pet bear that would kiss him. The bear got a Tootsie Roll each time he did that stunt. The catch was that Newman had to hold the Tootsie Roll in the corner of his mouth. It terrified Newman. Once, the bear actually took a hold of the whole side of the actor's jaw, slowly closing his teeth around the Tootsie Roll before he lumbered away. Young, also a stuntman in the film, described a memorable ending to the filmmaking: "We were just a day or so away from wrapping. It was a night shoot and colder than you can imagine for Arizona. Everyone knew that John Huston [director] had a habit of giving a going away speech and sure enough, at four in the morning, he called everyone together. We were all freezing as he walked about on the porch, back and forth, telling us all what a great job we did. Finally, after about forty-five minutes, he was done. Everyone gave him a rousing hand clap. What he didn't know was we were really just trying to warm our hands."

Westerns still dominated this era, and yet Martin Scorsese's 1974 feminist drama *Alice Doesn't Live Here Anymore* would become one of the standout films of this era. Tucson played multiple roles as Socorro, New Mexico, Phoenix and as itself in this film about a newly widowed woman played by Oscar winner Ellen Burstyn on the road with her precocious son. "There was a part of me that wanted to erase everything of where I came from," Martin Scorsese said of the decision to make the film. The diner featured in the film where Burstyn's character waits tables was built on Main Avenue between Speedway and Drachman Street. Then, *Cannonball Run II* came to town, and it brought "a confluence of star power never before seen," as headlined by the *Arizona Daily Star*, with the likes of Burt Reynolds, Dom DeLuise, Dean Martin, Shirley MacLaine, Sammy Davis Jr., Frank Sinatra and Jackie Chan as its stars. Production on the film was riddled with controversy, mishaps, crime and intrigue from the get-go. The most heinous was a shooting on the night of July 20, 1983, that left a Pima County sheriff's deputy dead from wounds suffered while working off-duty guarding movie equipment.

Kris Kristofferson in *Cannonball Run II*. *Courtesy of Arizona State Library, Archives and Public Records, History and Archives Division, Phoenix.*

Hal Needham, Dom DeLuise and Burt Reynolds in *Cannonball Run II*. *Courtesy of Jack Young*

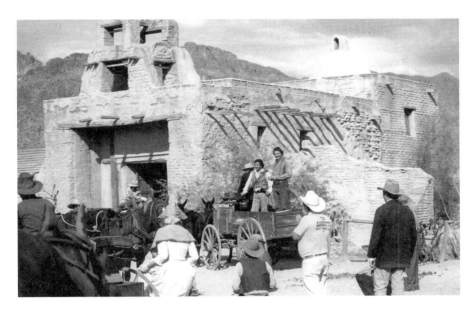

The Sacketts, starring Tom Selleck and Sam Elliott, was filmed at Old Tucson Studios in 1979. *Courtesy of Old Tucson Studios*.

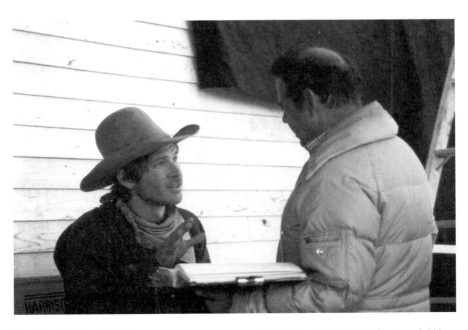

Harrison Ford behind the scenes on western comedy *The Frisco Kid* (1979). *Courtesy of Old Tucson Studios*.

Filmed on the University of Arizona campus, the far less problematic film *Revenge of the Nerds* (1983) portrayed a group of student outcasts that cannot get into fraternities and sororities, so the young men and women decide to form their own group. Concerned that the movie did not portray campus life in a representative way, the University of Arizona revoked permission for filmmaking on campus before public outcries made it reconsider, as long as the university was not mentioned anywhere in the film. Ironically, UA students skipped class to appear as extras in the film. In 1987, another school-based comedy, *Can't Buy Me Love*, the tale of nerd Patrick Dempsey who pays popular girl Amanda Peterson to be his girlfriend, was shot at Tucson High. Teachers let students out of class to audition for scenes. Paula Abdul choreographed the dance scenes in the film. The teens were paid cheaply, but in return, the production company donated a five-thousand-square-foot dance floor used in the film.

During the late 1980s, westerns and television shows once popular began to fall from favor with audiences, and Old Tucson was hurt financially. Few in the movie industry had thought of Tucson creatively as a place to shoot anything other than outdoor films and shows. By marketing contemporary films such as *Can't Buy Me Love* and *Revenge of the Nerds*, the long-running studio was able to stage a strong comeback, presenting Tucson as a modern, anywhere kind of place, contributing to the resurgence of the movie business in the 1990s. The 1993 remake of *Tombstone* was filmed in part at Mescal, as well as Old Tucson, Babacomari Ranch and Eglin; the film featured Val Kilmer in his favorite role as Doc Holliday and was narrated by Robert Mitchum, leading man and villain in countless films (perhaps most famously as Max Cady opposite Gregory Peck in the original *Cape Fear*). One of the ultimate spaghetti westerns, *The Quick and the Dead*, with Sharon Stone, Gene Hackman and Leonardo DiCaprio, was also filmed at the lovely Mescal in that year.

While many film studios throughout the state of Arizona have seen their heyday and are no longer in existence, Old Tucson continues to function and thrive as a 320-acre filming location and theme park, complete with theme areas: a mining town, a carnival, Town Square, the Mexican Mission Plaza and the Arizona Ruins. Located twelve miles west of Tucson in Tucson Mountain Park, the set is surrounded by miles and miles of pristine Sonoran desert and is open daily when filming is not in progress. Visitors enjoy seeing a real "slice of Americana," with stunts, gunfights and dancing saloon girls. Esteemed film historian and author of *Old Tucson Studios* P.J. Lawton summed up the experience, writing, "One of my favorite things

is to stand in the middle of Front Street [old name for Main Street] and listen to the wind. I can hear the call for 'action' and the voices of so many Hollywood stars that walked these same streets. The history of old Tucson is the story of the Western Film, gunfighters, Law officers, and Cowboys."

TUCSON TODAY

Tucson's golden age of filmmaking may have long passed, but the city still attracts a steady amount of movie projects. The vibe of this artsy desert city, with its natural surroundings and pro-film attitude, is a natural choice for a range of filmmaking—from coming-of-age stories *Spin*, *Goats* and *Lucky U Ranch* to new westerns like *Hot Bath an' a Stiff Drink*. Sam Mendes's romantic comedy road movie *Away We Go* was partially filmed at the J.W. Mariott Starr Pass Resort and Spa, and *Transformers: Revenge of the Fallen* was shot at Davis-Monthan Air Force Base and at Tucson International Airport. "It is a relaxed town, not jaded by too much filmmaking," said Victoria Westover, director of the Hanson Film Institute and producer of the narrative feature film *600 Miles*.

Arizona's documentary filmmaking community is also healthy and robust, particularly in the southern part of the state, with the availability of hands-on production classes at universities and nonprofit arts organizations such as Pan Left Productions. This region has become a kind of ground zero for border stories, as well as flora and fauna profiles. Despite meager fiscal support for artists, the city of Tucson has "a strong tradition of documentaries that have been shown nationally," commented Westover, who also produced *Apache 8*, the story of an all-woman wild land firefighting crew from Arizona's White Mountain Apache Tribe that was broadcast by PBS across the country. Too, there is a "coherent community for artists in Tucson," remarked Jacob Bricca, film editor for *Lost in La Mancha*.

Acclaimed 2011 documentary *Precious Knowledge* (also edited by Bricca) was produced by Tucson-based documentary filmmakers Eren McGinnis and Ari Palos of Dos Vatos Productions; it was about Tucson Unified School District's students and teachers fighting to save the Ethnic Studies class in an epic and historic civil rights battle against Arizona lawmakers. "My hope from the start was to bring local and national awareness to our dropout rates, or as we say, the push-out rates for youth of color," explained McGinnis.

Alma, an independent film directed, written and produced by independent filmmaker Yuri Makino, tells the story of a typical high school student in the Southwest. *Courtesy of Jeff Smith.*

Many key Tucson locales were used in *Alma*, such as this house painted with La Virgen de Guadalupe in Barrio Anita. *Courtesy of Jeff Smith.*

Working outside the hubs of filmmaking, McGinnis has produced twenty-one movies, including *The Girl Next Door*, shortlisted for an Oscar. "National audiences are hungry to see what is happening outside of Los Angeles and New York City. Our compelling stories and demographics make Tucson, Arizona, a wonderful place to be a documentary filmmaker," she added. "My films are a small part of a long tradition of capturing the unique light and beauty of the Sonoran landscape, culture and people, a special cinematic space that will continue to inspire filmmakers for many years." *Precious Knowledge* engaged audiences all over the country, inspiring them to address educational inequities in their own communities and to push for real solutions. McGinnis hopes that the next generation of filmmakers will continue to shine a light on educational injustices wherever they may occur.

The films of Yuri Makino, associate professor at the University of Arizona's School of Theatre, Film and Television, also exemplify this vibrant multicultural independent scene. *Alma*, a film Makino directed, co-wrote and produced, tells the story of a typical high school student in the Southwest who has no idea that she is an illegal immigrant. "*Alma* was inspired by a true story of a friend, who at nineteen years old was arrested, jailed and deported to Mexico, a country she never knew," she described. Makino succeeded in giving a voice to the experiences of a young Latina coming of age in the Southwest who has to face the hard reality of her immigration status.

The film uses many of the landmarks that give Tucson its unique flavor to establish the world of the character. "For *Alma*, we filmed mainly downtown to capture the uniqueness of Tucson. The script called for a liquor store, and we ended up shooting at the Midtown drive-through liquor store on Stone Avenue. Coming from California, I had never lived in a state where drive-through liquor stores existed. The drive-through feature, as well as the cinematic neon signage, made it an interesting shooting location, one specific to this area," explained Yuri. The subtle and moving film won numerous awards, among them the Ledo Matteoli Award for Best Immigrant Story at the 2007 Humboldt Film Festival. The daughter of Japanese and Swiss immigrant parents, Makino has spent much of her life and film career examining cultural borders and questions of identity. "Living here in Tucson, so close to the border, you become more aware of how borders function in all our lives: they are the places of division but also of transition, pride and transformation."

SNEAK PEAK: *600 MILES*

The United States/Mexico co-production *600 Miles* is the working title for a feature-length drama about a young Mexican gun smuggler and his relationship with the American ATF agent he kidnaps. The film is produced by Tucson filmmaker Vicky Westover's production company Fixer Films and Mexican production company Lucia Films. The film's LA-based writer and director, Gabriel Ripstein, is the son of noted Mexican director Arturo Ripstein. Mexican producer Michel Franco's film *After Lucia* won the prize of *Un Certain Regard* at the Cannes Film Festival. The film will star Academy Award–nominated actor Thomas Haden Church (*Sideways*) and up-and-coming Mexican actor Kristyan Ferrer. Filming will take place for twelve days in Tucson and southern Arizona. The film will be distributed in Mexico and the United States by Pantelion Films (backed by Lionsgate Entertainment and Grupo Televisa). Westover hopes that it is "a beginning of a trend for U.S.-Mexican co-productions in Arizona."

A DAY IN THE LIFE OF A LOCATIONS MANAGER, UNSUNG HERO OF MOVIEMAKING

"My joy comes with being able to satisfy the look," said Timothy Flood, a Tucson-based locations manager for movies such as *Goats*, *Ingenious*, *Geronimo* and, most recently, *Hot Bath an' a Stiff Drink 2*. "If an art director changes a picture around on a set, they're a genius, but I'm the one that found that building." Flood is an old hand in Tucson; local favorite Maynards Market was named for his grandfather Maynard Flood, an engineer on the Southern Pacific Railroad. In 1979, Flood was unemployed but had a friend who worked for an executive producer in Burbank who produced content for independent television channels. "I learned all of the production basics from these guys over an eighteen-month period and made a whopping $350 per week as their production assistant."

Flood returned to Tucson to set up shop and has become the go-to locations manager, scout and production manager for the film industry in southern Arizona. "A typical location scouting day comes after responding to

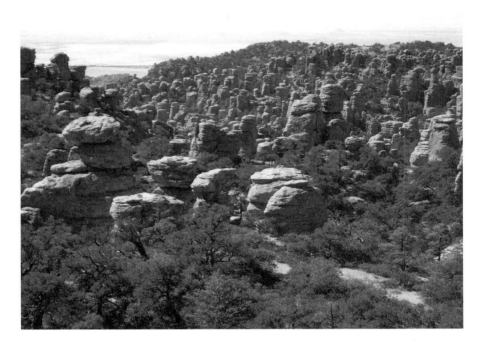

Tucson-based locations manager Timothy Flood's favorite movie locations in southern Arizona include Chiricahua National Monument (pictured here), Patagonia and urban Tucson. *Courtesy of Timothy Flood.*

a specific request, usually from a producer, who hires me to provide options for locations for a specific script, whether a feature film, commercial or still shoot." Flood analyzes the script, breaking down the main locations—vistas, roads, houses, ranches and so on. With a deep knowledge of the nature of filmmaking, Flood attempts to provide producers with looks that will enhance the film, coordinates local crew and sometimes even assists in casting. "There are so many characters that I meet while scouting and so many more during the shoot. Problems that come up usually create the most interesting situations, from the personal to the outrageous. There are usually quite a few laughs on a movie set, but the closer you get to the camera, the less laughs there are."

BEHIND THE SCENES ON HOT BATH AN' A STIFF DRINK 2

This is the biggest western film to shoot in the Tucson area since 1939's *Arizona*. Set in 1863, the original *Hot Bath an' a Stiff Drink* follows in the form of traditional westerns, John Ford's work, Clint Eastwood's *The Outlaw Josey Wales*, *Tombstone* and *The Quick and the Dead*. The storyline is simple and classic: After seeing their mother and father massacred by a rough group of outlaws, two identical twin brothers, Vance and Tom Dillinger, are separated when Tom is kidnapped by the outlaws. The two meet again after thirty years.

On the heels of the film's success, filming on the sequel to *Hot Bath an' a Stiff Drink* took place at the Mescal set and then other locations around southern Arizona: Greaterville Canyon, White Stallion Ranch and Old Tucson Studios. At the Mescal set, lead actor and producer Jeffery Patterson sat in his makeup chair, chatting gregariously on the film's beginnings and local locations. "I hope the film gives a younger generation an understanding of older westerns, where nudity and language weren't essential to storytelling." The project chose to film in Arizona despite the lack of any tax incentive for the incredible vistas that "just justified shooting [here] over New Mexico and Texas."

After our interview, I observe the day's filmmaking. It is extremely windy but sunny, perfect weather. The Mescal set is a western town replica, with requisite shops: a taxidermist, an undertaker, "Mom's Café" and a community bank. It is a beautiful, colorful mix of pinks, blues and an unforgettable bright-yellow territorial-style house with a wide porch. I soon learn that main character Vance's house on the set is the same one used in the hit series *Little House on the Prairie*. The day is also incredibly busy, with all the extras, cast and crew here. Extras in the film are all local, with crew hailing from Arizona and Los Angeles. Actors are dressed in full 1800s costumes. The vibe and energy is extremely good. The assistant director incites a western square dance sequence that is so much fun I soon want to join. "Enthusiasm is very important," said Patterson's assistant, especially for an independent film because "you can make an incredible project if you have people excited to be there."

This is also a workplace. There is a lot of waiting and setting up. I sit in a movie-style chair and smell the aroma of bacon. Everyone is very friendly. A nine-year-old extra and student at a local school district explained that this was her first movie; she thought that "everything is pretty cool." All of a

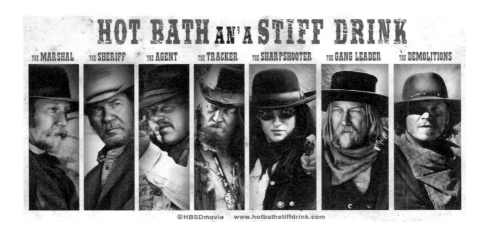

Hot Bath an' a Stiff Drink, starring Jeffery Patterson, Timothy V. Murphy and Mirelly Taylor. *Courtesy of Hot Bath an' a Stiff Drink LLC.*

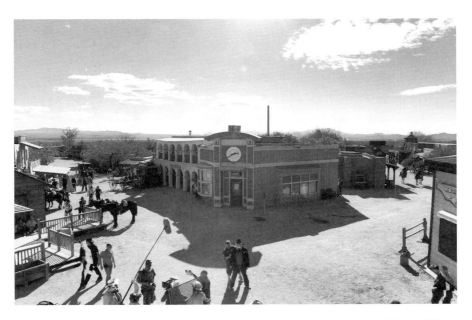

Hot Bath an' a Stiff Drink filming at Old Tucson Studios. *Courtesy of Hot Bath an' a Stiff Drink LLC.*

Aloft at the Loft Cinema

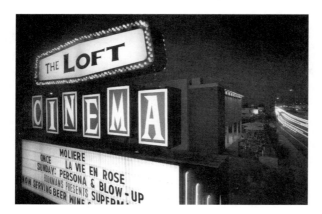

The Loft Cinema provides the Tucson community with year-round access to numerous films and filmmakers through signature events, screenings and festivals. *Courtesy of Loft Cinema.*

Nonprofit art house the Loft Cinema is "dedicated to creating community through film, honoring the vision of filmmakers, celebrating ideas and promoting the appreciation and understanding of the art of film." As art houses have been dying out across the country since 2002, the Loft has provided the Greater Tucson community with year-round access to numerous films and filmmakers through signature events, film screenings and filmmaker Q&As at this landmark theater. One of the highlights for audience members are its presentations prior to a film's showing detailing the historical background of the film. Additionally, the Loft hosts two film festivals per year—an international film festival in November and a free children's film festival every July. Since its beginnings, more than 450 film industry professionals and scholars have visited the theater. Over the years, the Loft has received countless honors in its role as Tucson's premier art house theater, including being voted Best of Tucson by Tucson Weekly yearly since 2002, a Lumie from the Tucson Pima Arts Council and selection as an official venue of the Sundance Film Festival in 2012. Contact: 3233 East Speedway Boulevard, Tucson, AZ, 85716, (520) 795-0844, www.loftcinema.com.

sudden, everyone is quiet, and the director yells, "Action" and then, "We're rolling. Keep it quiet please." The director gives feedback such as "Nice job" or "More animation." Filming goes on for a few minutes at a time. It is both all in a day's work and incredibly exciting. Tombstone-based actress and costumer Jenna Miller commented that "movies are more fun because there are more people collaborating than on a television show." I will never forget the sight of the actors on horseback against the blue vistas, windswept dusty street and brick "Kilmer" Saloon.

A week later, I arrive at the film's base camp, located at the Lazy K Bar Ranch just outside Tucson in the beautiful Sonoran Desert. Clouds are forming on the horizon, and the air is soft and cool. The set for the day is a five-minute walk up the trail, located in a canyon. I am standing behind the camera with sweeping expanses of the desert above and all around us. I can see the ranchlands below, and red cliffs tower above. Today, I watch a key scene with lead actor Jeffery Patterson, who is lying on the ground in shackles. This is his defining moment. The director yells, "Cut." The writers of this particular scene hail from Louisiana and New York; they are excited because they are getting the chance to watch a scene they wrote together. We discuss western film clichés. This is their first movie; they say that writing a movie is like having a baby. Then "Settle please", "Action!" and suddenly everyone is quiet again. The actors gallop through the desert. It is just so very exciting, and when the camera rolls, something truly magical happens. I am transfixed as I listen to the actors. The highlight of the day is the second scene I observe, which appears to be a shootout with characters on the cliffs above me. The enthusiasm is contagious. It is obvious that people here love what they do. I shake Patterson's hand after filmmaking wraps for lunch (rice, curry, black beans, salad, steak, cheese and everything else you could want; everyone eats together family style). The weather changes about five times today, from perfect in the morning to gray and warm, sunny, windy, then too cold and stormy.

After lunch, I walk the grounds of the now closed Lazy K Bar Ranch. It was obviously once a great guest ranch with all the necessities—a cookout area, casitas, hiking trail and lodge. Now it is like a ghost town. The melancholy silence is a sharp contrast to the lively, creative atmosphere of the filmmaking a short walk away. They go into the evening and face some very harsh conditions. I am amazed at the dedication and sheer effort that this line of work takes. I quickly notice that on a film set, people assume that you know what they are talking about. So you have to play a lot of catch-up. I leave knowing what a line producer actually does, that screenwriters

frequently partner up and that this is a place with all kinds of people in front of and behind the camera. There are two extreme personalities on set: discussions of Apple TV and *Breaking Bad* along with antique guns and saddles. But they all work together as a team. Since 1911, eight hundred films have been made in southern Arizona including shorts and feature-length films, with nearly one hundred high-profile, big-budget movies that have played nationwide. This legacy will no doubt continue with films such as the *Hot Bath an' a Stiff Drink* trilogy in the making.

CHAPTER 3

A WALKING TOUR OF TUCSON'S FILM AND TELEVISION HISTORY

HOTEL CONGRESS
311 East Congress Street
(520) 622-8848
Kurt Russell, Val Kilmer and other stars used this historic Southwest Art Deco landmark as a favorite hangout during the making of 1994's *Tombstone*; Renee Russo and Kevin Costner appear in a scene in front of the hotel in *Tin Cup* in 1996. Across from the hotel, *Stephen King's Desperation*, an ABC TV movie, used Congress Street for Saigon, Vietnam. The indie *Desert Bloom*, starring Jon Voight, also used this portion of Congress Street to stand in for 1950s Las Vegas.

PUEBLO HOTEL & APARTMENTS
145 South Sixth Avenue
A scene from 1972's *Pocket Money* was filmed at this historic building featuring the "Diving Girl" neon sign. The film stars Paul Newman and Lee Marvin and takes place in 1970s Arizona and northern Mexico. Portions were shot at Southwestern Studios in Carefree, Arizona, as well as at a facility originally built by cast member Fred Graham.

TUCSON ON FILM

Tucson's extensive array of film locations span its vast city environ and neighboring public and private lands, towns, ranches and missions. The breadth is truly staggering. With Old Tucson Studi international reputation, it is easy to overlook the city itself and its stellar filmmaking history. It is the areas of Armory Park, Barrio Viejo, Downtown and El Presidio that provide a representative taste of the city's film history offering a wealth of settings and venues to explore. With such large concentration of movie-related sites still in existence and authentica preserved, Tucson is the ideal Arizona city for locals and visitors to walk ir the footsteps of your favorite stars from classic Hollywood and silent films comedies, westerns, television movies and hip Indies. Watch the films, the take to the streets and meander your way through the movie set that is the city of Tucson.

Film
tucson

El Minuto Café
354 S Main Ave
El Tiradito Shrine
420 S Main Ave

W Simpson St

★

Elysian Grove Market
400 W Simpson St

Design by Jennifer Yamnitz. Courtesy of the Tucson Film Office.

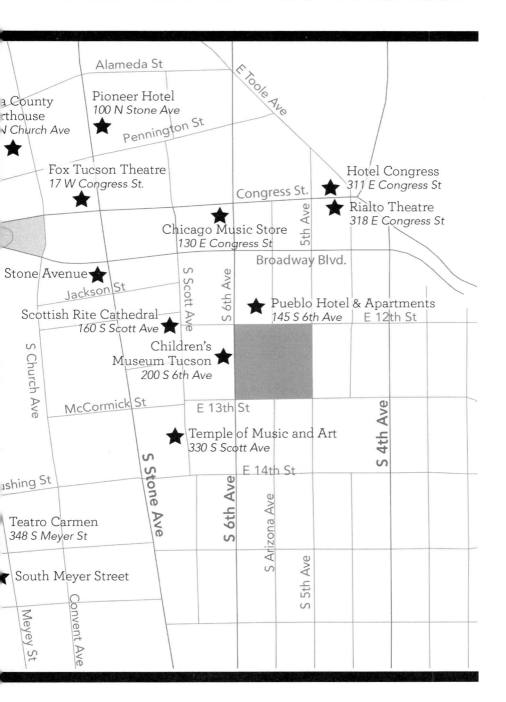

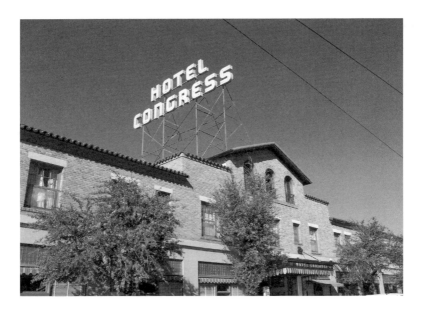

Author's collection.

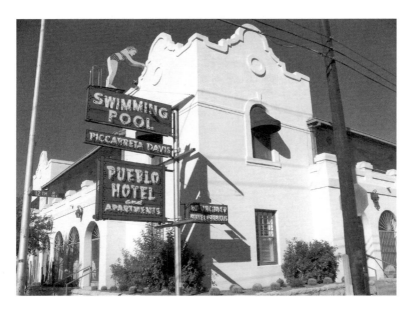

Author's collection.

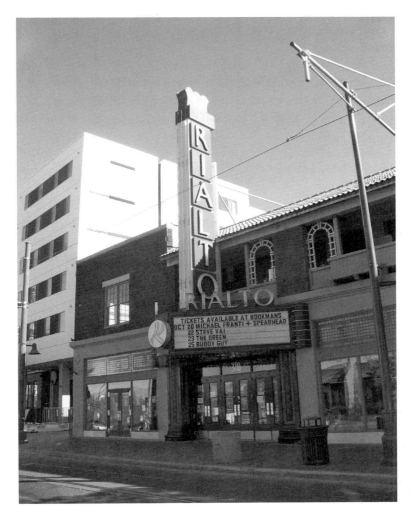

Author's collection.

RIALTO THEATRE
318 East Congress Street
(520) 740-1000
Producer Mary Pickford's 1936 musical farce *The Gay Desperado* (starring Ida Lupino and Leo Carillo) was filmed partially inside this notable long-running theater.

CHICAGO MUSIC STORE
130 East Congress Street
(520) 622-3341
A young, pre–*Taxi Driver* Jodie Foster observed that "Tucson is the weird capital of the world" at this charismatic store in Martin Scorsese's *Alice Doesn't Live Here Anymore*. Foster's character also takes guitar lessons in the store.

FOX TUCSON THEATRE
17 West Congress Street
(520) 547-3040
The classic western *When a Man's a Man* premiered at this historic theater and 1929 Southwest Art Deco movie palace. A work by best-selling novelist Harold Bell Wright inspired this film, as well as *Mine Behind the Iron Door*. Six other films have also had their world premieres at the Fox, including *Chasing Rainbows*, *Billy the Kid*, *Arizona*, *Let Freedom Ring*, *Chicken Every Sunday* and *The Deadly Companions*. Each year, the Fox Theatre screens many classic films for free for the general public. John Wayne's ghost is said to haunt the theater's balcony area.

PIONEER HOTEL
100 North Stone Avenue
No longer operating as a hotel, this was the place for Old Hollywood glamour—and action—in its day. The premiere party for *Arizona* (1940) was held here to great success and fanfare. Then, in 1953, Robert Wagner threw Joanne Woodward to her death from the top of the hotel in *A Kiss Before Dying*. Armory Park and the former Valley National Bank (now the Chase Bank) were also featured prominently in this superb example of film noir.

STONE AVENUE
Action sequences and a bank robbery scene for the Sidney Poitier–directed comedy *Stir Crazy* were filmed along this city street.

SCOTTISH RITE CATHEDRAL (SCOTT AVENUE)
The interior room of this lovely location (on the National Register of Historic Places) doubled as the U.S. Congress, with an "initiation" scene from *Revenge of the Nerds* also being filmed inside.

CHILDREN'S MUSEUM TUCSON
200 South Sixth Avenue
(520) 792-9985
As the former Carnegie Library, this elegant building was seen in *A Kiss Before Dying*, with Robert Wagner and Joanne Woodward, based on Ira Levin's book of the same name. Levin would later write *Rosemary's Baby*.

PIMA COUNTY COURTHOUSE
115 North Church Avenue
(520) 724-3171
Barbra Streisand and Kris Kristofferson tie the knot in front of this charismatic pink and tile domed building in the remake of *A Star Is Born*, filmed on location in both Phoenix and Tucson.

TEMPLE OF MUSIC AND ART
330 South Scott Avenue
(520) 884-8210
Identical in style to the Pasadena Playhouse, many feature and television movies have used this historic property for filmmaking, world premieres and film festival parties since the early twentieth century.

Author's collection.

EL MINUTO CAFÉ
354 South Main Avenue
(520) 882-4145
Since 1939, this authentic café has served the community of Tucson. Grab some amazing (and fast!) Sonoran specialties while you browse photos of star customers Danny DeVito, Rene Russo, Gene Hackman and Esai Morales (*La Bamba*).

EL TIRADITO SHRINE
420 South Main Avenue
Known as the "wishing shrine," El Tiradito is the only Catholic shrine dedicated for a murdered man. El Tiradito was featured in the 1996 TV movie *Blue Rodeo*, with Ann Margaret and Kris Kristofferson. Catch Ann Margaret in *The Villain*, shot at Old Tucson Studios.

SOUTH MEYER STREET
Located in the Barrio Viejo (Old Neighborhood), this historic street was featured in the 1914 silent film *The Caballero's Way*, the first of the immensely popular *Cisco Kid* movies, and it also saw much excitement from the local community during filming of *The Gay Desperado*. The Barrio also doubled for 1950s Mexico in James Redford's moving coming-of-age film *Spin*.

ELYSIAN GROVE MARKET
400 West Simpson Street
(520) 505-1924
Originally a market for the neighborhood and later a bed-and-breakfast, this private event space is easily one of the most beautiful buildings in Tucson. It was named Elysian for the lush greenery of the pond that once existed here, and the suspenseful TV movie *An Unfinished Affair*, starring Jennie Garth (*Beverly Hills 90210*), filmed here, as did *Boys on the Side*, with Drew Barrymore, Whoopi Goldberg and Mary-Louise Parker. A private home located at 92 Simpson Street was featured in *Spin*.

Author's collection.

TEATRO CARMEN
348 South Meyer Street
Boys on the Side (1995) filmed at this iconic Spanish-language theater and cultural center of early twentieth-century Tucson. The building attached to Teatro Carmen to the south was also featured in 2012's indie hit *Goats*, with David Duchovny and Vera Farmiga.

SOUTHERN ARIZONA

Town and Country

Oh, what a beautiful mornin'. Oh, what a beautiful day! I got a beautiful feelin'
everything's goin' my way.

–Oklahoma!, *1955*

Traveling east of Tucson unfolds a landscape that is lyrical, glamorous, rugged and unforgettable. The idyllic ranch country of Santa Cruz and Cochise Counties—with Empire, Rain Valley, Babacomari, Triangle T and Circle Z ranches—has hosted a wealth of moviemaking since the beginning of the twentieth century. This is a place to slow down and dream. A must is to travel down Arivaca Road toward the sleepy, artsy, hippy enclave of Arivaca. This is a journey into the sky, your eyes constantly drawn upward. The soft, green grasslands and mountains are a feast for the senses. White clouds form shadows across the gentle hills and beauty of the expansive ranchlands of Sopori Ranch, Bella Vista Ranch and Walking J Farm. With exceptional conditions for agriculture, the cattle ranches begun here in the late nineteenth century are still working today, some by the descendants of the original homesteaders. In this landscape that is nearly mythological, James Redford made his debut coming-of-age film *Spin* in 2003.

THE EMPIRE RANCH

Any discussion of movie history in this region inevitably bears mentioning the Empire Ranch, a transcendently beautiful and vast empire of grassland habitat an hour's drive from Tucson. First established in the 1860s by Tucson businessman Edward Nye Fish, Walter L. Vail, a native of Nova Scotia, and partner Herbert Hislop, an Englishman, expanded the original holdings of the ranch to include more than 1 million acres, making it one of the largest cattle enterprises in Arizona's history. In 1928, Frank Boice and his family became the ranch's sole owners and hosts to Hollywood production companies. It was during their ownership that a number of classic western movies were filmed at the ranch, including *Winchester '73*, *3:10 to Yuma* and *Oklahoma!*

Throughout the ranch's history, numerous well-known western movies and TV series continued to be filmed on or near the property. "Most people don't realize just how huge some of these ranches like the Empire really were," explained Emil Franzi, board member of the Empire Ranch

As green as Ireland; the ranchlands of Arivaca. *Author's collection.*

Foundation. "The Empire at different times was sprawled over three counties. *Red River* was filmed as the cast moved the fictional herd in a circle over the big valley, which can be identified by the different mountain ranges from the Santa Ritas to the Whetstones to the Mules. Most movies credited to Old Tucson and Mescal often had scenes shot in the area the Empire once encompassed." Since 1997, the Empire Ranch has been a nonprofit organization that preserves the heritage of its buildings while serving the community through programs, events, trail rides and tours. "The annual Empire Ranch summer movie brings in the family members of that great generation of now-gone stars and stories, from people such as Tucsonan Pam Marvin and Glenn Ford's son, Peter, who have added to the legends, particularly the stuff we're told off the record."

RAIN VALLEY AND ELGIN

Everything in film acting is thinking. The camera picks up what you think and not what you say or do.

—*Walter Brennan* (Red River)

A short distance from Empire sits the Rain Valley Ranch. Vineyards and the towering drama of the Mustang Mountains, named because of the herds of wild mustangs that once lived there, protectively cup Rain Valley. In 1948, Howard Hawks's *Red River* was filmed on location here, as well as at Empire and in the nearby small town of Elgin. Starring John Wayne and Montgomery Clift, *Red River* is the story of a great early cattle drive running from San Antonio to 1868 boomtown Abilene, Kansas.

Hawks and Wayne maintained a lifelong friendship, also working together in *Rio Bravo* and *El Dorado*. Film professional Michael Ohrling remembered filming a public service announcement featuring John Wayne on Wayne's Maricopa Ranch. Early in the morning, Wayne was in the ranch bunkhouse chatting with the ranch hands. "We were waiting around, and all of a sudden, a big black limo shows up at the bunk house and out steps an elderly man with a cane. No sooner did that man get out and started walking towards the bunkhouse then out comes John Wayne saying, 'Howard' [Hawks], and they were soon embracing. I'll never forget that." Today, it is Elgin's wineries more than its movie history that attract tourists, eager to sample from its local

vineyards along the Sonoita-Elgin Wine Trail while soaking in the sunflower-dotted landscape, a delicious respite from the Sonoran Desert to the west. At night, visitors and locals chow down in Elgin's twin town Sonoita's historic Steak Out restaurant, with its cozy vibe and amazing aromas; it was an old haunt for the Hollywood crowd in the days of classic westerns.

SAN RAFAEL RANCH

The Southwest's Loveliest Lady

Traveling south of Sonoita, one will eventually reach the spacious and beautiful San Rafael Valley. During the mid-1880s, Lancaster County, Pennsylvania native Colin Cameron built a lavish mansion on a small hill overlooking the valley. Cameron imported a large amount of Hereford cattle from England to stock the range, a breed well adapted to the region. In 1903, Colonel William Greene purchased the house and land grant. The ranch grew to encompass roughly 600,000 acres and operated on both sides of the border, with the Green Cattle Company headquarters based in Cananea, Sonora. Although

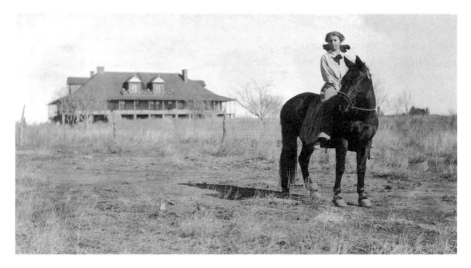

The San Rafael Ranch is one of Arizona's most charismatic movie locations. *Courtesy of Arizona State Parks.*

cowboys and ranch managers lived on the property, no Greene family members lived in the house until 1958, when Florence Greene Sharp moved there with her family from California. With its large expanses of uninterrupted private land and ready supply of cattle and sheep, the San Rafael Ranch is one of Arizona's most iconic movie locations. The lovely brick ranch house, with its white verandas on three sides, was first used in the musical *Oklahoma!* with Gordon McRae, Shirley Jones, Rod Steiger and future mayor of Tucson Lew Murphy; it also filmed at Agua Linda Farms. The house was used memorably in *McLintock!* starring John Wayne and one of Hollywood's most beautiful women, Maureen O'Hara.

In the 1970s, director Blake Edwards (*Breakfast at Tiffany's* and *Days of Wine and Roses*) came looking for locations for his film *The Wild Rovers*, and so Tucson locations manager Jack Young took his entourage around. Young had previously been a stunt double for Montgomery Clift and Clark Gable, working on numerous westerns, including *The Searchers*, *Rio Bravo* and *The Misfits*. Young recalled, "There were several in his company, and also his wife, Julie Andrews, was along. They needed a big house circa 1878, so I took them to San Rafael Valley. Mrs. Sharp, the owner, was a tough old bird that I had known and worked with many times. She didn't take any crap from anyone." Lisa Sharp remembered sitting with her mother when Jack and the crew showed up. Mrs. Sharp invited them in, and they were explaining what was needed for the film. "Julie Andrews…had a beautiful fur coat cut in a Levi Jacket pattern," remembered Lisa. "Suddenly, Mrs. Sharp stood up and asked me to go to the kitchen with her," added Jack. "I was scared because I didn't know how these high-powered people would take this. She poured me

1950s
Oklahoma!
The Big Country

1960s
The Great White Hope
Heaven with a Gun
McLintock!

1970s
The New Maverick
The Young Pioneers
Tom Horn
The Wild Rovers

1980s
Little House on the Prairie

1990s
The Fantasticks
Arizona Dream
Pontiac Moon
Young Guns II
Blue Rodeo

a cup of coffee, sat down and said, 'I don't like those people, Jack. So I'm not going to allow them to use my place.' I was mortified...about to lose a good job. My mind was racing, and all of a sudden, it hit me. I got up, asked her to come to the kitchen door. I pointed to Julie and asked, 'Do you know who that is?' She looked and said, 'She does look familiar.' I said, 'Mrs. Sharp that is Mary Poppins!' She ended up letting them shoot. Julie was extremely nice to her."

During the filming of *The Young Pioneers* in the late 1970s, film crews brought out ten thousand plastic grasshoppers for the shoot because there was an invasion of locusts in the film story. "We found plastic grasshoppers for years after that," Lisa said. Although Lisa left in 1999 after the ranch's sale to the Nature Conservancy, she has since penned a memoir of growing up on the ranch titled *A Slow Trot Home*. "Every rancher has a bond with the land, the land that supports their lifestyle, their family—it is their world. They know it as well as they know the back of their hand. To every rancher, their land is unique because they love it. San Rafael is no different to our family. It is unique because at one time it was ours, and that love stays in the soul no matter where you are." Today, the ranch house is a centerpiece of the San Rafael State Park, and although there are currently no plans to open the park to the public, curious visitors may traverse roads in the general vicinity of the iconic house.

NOGALES

The name of the town refers to a grove of walnuts. As the seat of government for Santa Cruz County, Nogales has witnessed much history and moviemaking, although it is perhaps more well known in recent times for its troubles with drug smuggling and illegal immigration. For moviegoers, the region is most familiar for Steven Soderbergh's *Traffic* (2000), filmed in Nogales, Arizona, and Nogales, Sonora. Since then, there have been many documentaries of national and international note focusing on border and immigrant issues filmed in and around Nogales, putting an intense spotlight on southern Arizona in the past decade. These include *Who Is Dayani Crystal?*, directed by British filmmaker Marc Silver, which won a Sundance cinematography award, and *The State of Arizona*, directed by New York–based filmmaker Carlos Sandoval.

The Undocumented, another such film directed by New York–based Marco Williams, aims to make "visible what is essentially invisible— the deaths of undocumented border crossers along the United States– Mexico border, specifically in southern Arizona," explained Williams. Since 1998, more than 2,500 dead bodies and skeletal remains have been found in the surrounding Sonoran Desert. *The Undocumented* puts viewers directly into these environs—the desert where bodies are found, where migrants are in distress and where migrants are apprehended; it also takes the viewer into the morgue and the homes of Mexican families. Although many institutions are trying to help by leaving water in the desert and by helping to find those who are missing, "all were surprised to see what the others do," observed Williams.

Rodrigo Reyes's *Purgatorio* is an unusual documentary that looks at the border as a stage of human nature. *Purgatorio* is a journey into the heart of the unique region of southern Arizona. The film "doesn't play into the polarizing debate that surrounds immigration right now but instead goes past the politics to look at our issues as human beings. I've always thought that borders are the most naked parts of every country," said Reyes. "That's where all the trappings and pretensions fall apart, and we can see bare reality." With many adventurous memories of filmmaking, one stands out for its director: "In early October, the small crew got trapped in the hills west of Nogales for the better part of a day, our vehicle lodged deep in the sand of a ravine. We had been driving off-road, looking for migrants to interview or for good shots of the border fence. The sun was coming down, and we knew we would soon be the prey of coyotes and drug smugglers. We struggled for hours to get free and lost the entire shooting day. By the time we dug out the van, we had run into scorpions, cut down a few small pine trees and dug up all the usable rocks lying in that spot."

Border residents are amazed to see their lives in the context of a larger whole. "The border is continuously in the media, but ironically, it is not very well understood because it is always politicized," commented Reyes. Films such as these contribute to a more profound understanding of the contemporary reality of this historic region.

BISBEE: EXCELLENCE IN INTERACTIVE STORYTELLING

Former mining community and famously offbeat border town Bisbee has a long and unabashedly proud history of moviemaking, beginning in the 1950s. *Cannonball Run II, Young Guns II, Roswell* and, most recently, *Stephen King's Desperation* have all shot on location in Bisbee. The new documentary *Bisbee* will be the town's first film actually about Bisbee. The film aims to show a nonfictional side of the town while providing deeper insight into the wider issues of rural America. Directed by Jeff Soyk along with media artist Allison Otto and independent filmmaker Elaine McMillion, the interactive documentary is set to be released in 2015.

Although many documentaries feature local issues, this film is unique. "Traditional documentaries are viewed in theaters and encourage a lean-back, passive viewership," explained Soyk. In contrast, an interactive documentary like *Bisbee* "incorporates a new lean-forward aspect, where viewers have the opportunity to become involved on a variety of levels," he explained. *Bisbee* was inspired by the award-winning interactive documentary *Hollow*. Boston native Soyk lived in Bisbee previously and, awed by the town's beauty, history and people, has always wanted to share the town through film.

In many ways, Bisbee is representative of rural communities in the United States. "Many of the issues being discussed by senators in the halls of power back east are the same issues being lived on a daily basis in Bisbee," noted Soyk. Because Bisbee is such a small, interdependent community, these issues are felt in a very intense and immediate way not often felt in larger cities. "If one or two small businesses close, it can impact all the others on the same street." Stereotyped as barren, the Sonoran Desert region in particular is often overlooked. "There's a vibrant, rich history in southern Arizona, a beautiful landscape and an amazing community of people in Bisbee who want to help guide their town into the future."

Between 2000 and 2010, Bisbee's lack of econommic opportunity caused many of its young people to flee to larger cities—a problem compounded by the fact that Arizona's economic decline in 2009 was the second highest in the nation. The documentary strives to address these issues and help provide positive options for the future. Bisbee's mayor, the Bisbee Mining and Historical Museum, the Central School Project and the Bisbee Youth Media Project have all collaborated on the film to share "how they see the town and the issues the community faces…The goal of the project is to help shed light on what life is really like in rural southern Arizona, to bring about

positive change in Bisbee and help build a solid foundation for the future." Through documentaries such as these, Arizonans can explore their past and the struggles in their communities and then create changes for the future.

BENSON: GAMMONS GULCH MOVIE SET AND MUSEUM

The Gammons Gulch Movie Set and Museum property is much more off the beaten path compared to Old Tucson Studios, with a long winding desert road leading up to the entrance. Since its beginnings, Gammons Gulch has seen thirty-one movies and four music videos (including one with Alyssa Milano), as well as numerous commercial shoots. With its original well-preserved buildings, the western-style town replica, complete with a jail, a saloon and a Wells Fargo bank, has functioned and appeared in period films ranging from the late 1870s to the mid-1920s. "It's like stepping back into time because

Gammons Gulch Movie Set and Museum. *Author's collection.*

Filmmaker in Focus: Frances Causey

The award-winning 2012 documentary Heist: Who Stole the American Dream *was co-directed, produced and written by Tubac, Arizona local Frances Causey. The film traces the worldwide economic collapse to a 1971 secret memo entitled "Attack on American Free Enterprise System," leading to the global financial crisis of 2008 and the continued dismantling of the American middle class. Offering solutions for a brighter economic future,* Heist *played in film festivals worldwide and was a New York Times Critics' Pick. Warm and unpretentious despite her incredible life accomplishments, Causey was previously a producer for CNN for fourteen years. Although* Heist *is far-reaching in topic ("We took a huge story, and most people just take a facet"), many elements of the film were inspired by local issues in southern Arizona. "When I first moved to Arizona, I was really blindsided by the militarization of the area; I had never seen anything like migrant smuggling." Causey began to understand the profit motive in smuggling and the ultimate transformation of the United States into a low-wage economy, and the idea for the film was born. Causey has three new documentaries in the works, including the story of the president of Uruguay, tentatively titled* Duh-mock-ruh-see, *which she describes as a personal look at the state of our democracy.*

of its authenticity," said Jay Gammons, the warm and loquacious owner. A former children's hospital worker, Jay stumbled on ten acres for sale on a trip to nearby Benson one fateful day. Looking at the bare land and mountains, he immediately said to his wife, "What a place to build an old western town." The family has called Gammons Gulch home since 1978.

The set maintains a wonderful working relationship with regional filmmakers, actors and extras, "the backbone of a movies' success," observed Jay, although it functions primarily as a prop rental and set-decorating service for movies. Antiques have been donated over time for its museum and set, including Elizabeth Taylor's chair from the film *Poker Alice*. Hailing from Rhode Island, Jay grew up in Tombstone in the 1950s watching westerns. As a young boy, Jay was an extra in the classic western *Winchester '73* with Jimmy Stewart and played a military policeman in cult-classic *Night of the Lepus* with Janet Leigh, shot in nearby Sonoita. Gammons

was also an extra in *McLintock!* In one scene in the film, Gammons was asked to hold a mug of beer while standing up in the wagon; he was "plastered," he said, because that particular scene with Wayne and O'Hara was shot more than ten times.

Photographs of Gammons with John Wayne during the filming of *Rio Bravo* and again with Johnny Cash during the remake of *Stagecoach* proudly adorn the walls of the saloon. Gammons's father was personal security for John Wayne when the actor came to Arizona. "They got along real well. Wayne was tough but fair; there will never be another." Jay began to work with his father as personal security for actors and as a bodyguard for Ava Gardner during filming of *The Life and Times of Judge Roy Bean*. In the film, Ava played Lily Langtry. Although she was in her fifties, Gammons remembered that she was so beautiful she looked thirty. Ava was "a sweetheart, very down to earth." Regarding all these Hollywood legends, he colorfully explained for the common folk, "they put their pants on the same way, but some of the pockets have more money." Today, Gammons Gulch contributes to the filming history of southern Arizona by catering to independent, low-budget and student films, all of which could in return bring other films to the state, Gammons hopes.

CASA GRANDE AND FLORENCE: LOST MOVIE HISTORY

Located almost equidistant between Phoenix and Tucson, Casa Grande has always been primarily a quiet farm community. Its closest neighbor, silver mining boomtown Florence, was founded in 1866 and had cattle ranching from its earliest days. Today, "both towns are motivated to preserve their history," explained Chris Reid of the Pinal County Historical Society.

The 1998 Warner Brothers well-reviewed feature film *Three Kings*, starring George Clooney, Mark Wahlberg and Ice Cube (alumnus of the Phoenix Institute of Technology), was shot in Casa Grande at the nearby Sacaton copper mine. In the film, three soldiers search Iraqi villages for hidden gold bullion during the close of the Persian Gulf War. The film was part of a series of Warner Brothers films done here during the same period, including *Tin Cup* and *The Postman*. The owners of the popular Lebanese restaurant Le Meditteran in Tucson became the only Tucsonans to make the final cut for

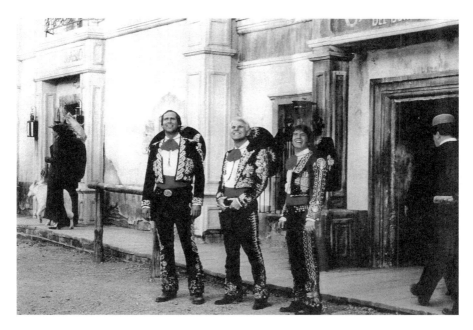

Three Amigos, starring Steve Martin, Chevy Chase and Martin Short. *Courtesy of Old Tucson Studios.*

The ranch house used in *Murphy's Romance*. *Courtesy of Pinal County Historical Society.*

Sally Field in *Murphy's Romance. Courtesy Pinal County Historical Society.*

Arabic speaking parts in the film. The Abi-Ads even added a Three Kings lounge to their restaurant in honor of the experience.

Florence has a lengthy and diverse moviemaking history, including hit modern films such as *Three Amigos* and *Posse*, as well as, notably, *Murphy's Romance* in 1985. Sally Field stars in the latter as Emma, a divorced woman with a teenage son, played by a young Corey Haim, who begins a new life and horse ranch business in a small town. James Garner plays Murphy, the town druggist who directs business her way. Murphy's Drugstore, the primary setting for the film, still exists but now houses an insurance business. The building was a drugstore in the 1930s but had been used for storage at the time the movie was filmed. Requiring the construction of a ranch house and barn, the film company ended up buying more than $100,000 of wood and other materials from a flagging local lumberyard, eventually adding almost $1 million per month to the local economy.

Florence's state prison has served as a premier movie location for many of its feature films, starting with 1921's *Three Sevens*. In the film, Antonio Moreno plays an innocent man convicted of manslaughter and unjustly imprisoned. The silent film era's Antonio Banderas, Moreno also had a part in the classic western *The Searchers*. In *The Way to the Gold*, Jeffrey Hunter

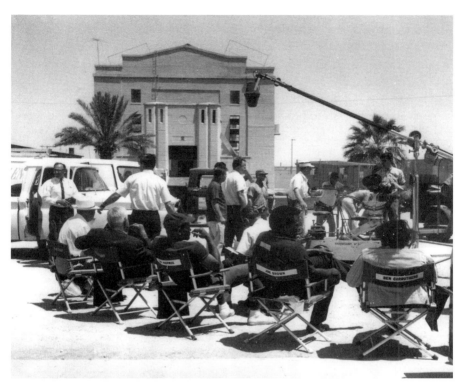

Above: The making of *Riot* in Florence.
Courtesy of Pinal County Historical Society.

Left: Prison warden Frank Eyman in *Riot*.
Courtesy of Pinal County Historical Society.

played a paroled inmate, a part originally offered to Elvis Presley in 1957. Prison warden Frank Eyman appeared as the warden in the film. Eyman would appear again in 1969's *Riot*, a movie starring NFL Hall of Famer Jim Brown and Academy Award winner Gene Hackman. Directed by Buzz Kulik, *Riot* was the first film to be entirely made in an active prison. Fifty-six inmates appeared in the movie, along with a few prison staffers. The world premiere of the film was also held at the prison. In the 1970 film *Run, Simon, Run*, Burt Reynolds played a Tohono O'odham man named Simon Zuniga, returning to his people after unjustly serving for the murder of his brother. To clear his name, he begins an exhaustive search for the killer. The film would be costar Inger Stevens's last before her suicide.

In 1980s, *Stir Crazy* featured Gene Wilder and Richard Pryor as two men framed for a bank robbery who make their prison escape during a rodeo. The Arizona State Prison used money from the movie to build its rodeo grounds. Filmmaking at the prison stayed quiet until 2006, when the opening scene to *Wild Seven*, with Robert Forster and Richard Roundtree, was filmed at the prison's entrance.

YUMA

Arizona's Middle East

Neither version of classic western *3:10 to Yuma* was ever actually filmed in Yuma. This incredible fact notwithstanding, some of Arizona's earliest and most charismatic filmmaking occurred in the vicinity of this sleepy city-town on the California border. The infamous Yuma Territorial Prison was the site for Yuma's earliest films. The 1914 documentary *Life in a Western Penitentiary*, a silent film about prison life in the West, gave audiences a glimpse of the inside of a notorious territorial prison, the daily lives of the prisoners, dungeon scenes, inmates on death row and the convict burial grounds. Reportedly, one of the prisoners who appeared in the film was given permission to go to New York unescorted for the film's world premiere on the promise that he would return; he kept this word.

A 1917 silent drama, *The Honor System*, known as the world's first socially conscious prison film, was also made at the location. As a call for prison reform, the film tells the story of an innocent man convicted of murder in a prison run by three corrupt administrators. Pioneering director Raoul Walsh even stayed overnight at the prison to get a feel for the atmosphere. The prison would see additional moviemaking much later with less cerebral films, such as Sylvester Stallone's *Rambo III* in 1988, filmed in Rambo Canyon as well. In 2011, the comeback western *Ambush at Dark Canyon* (formerly known as *To Kill a Memory*) featured retired country singer Kix Brooks of Brooks & Dunn and was filmed extensively at the prison, fulfilling Kix's lifelong dream of playing a cowboy in the style of Clint Eastwood.

Sand dunes. *Courtesy of Yuma Visitors Bureau.*

Isolated by mountains and vast stretches of pristine Sonoran Desert wilderness, Yuma is renowned for its majestic date gardens, lettuce fields and the state's only native palm trees. The early 1920s brought many Hollywood legends; Rudolph Valentino, Tyrone Power, Gary Cooper and Cary Grant have all shot films in Yuma and its environs. The city is the filmmaking gateway for the Imperial Sand Dunes, located in the extreme southeastern corner of California, a vast wilderness that has served as a location for *Morocco* (1930) with Marlene Dietrich and *Sahara* (1943) with Humphrey Bogart. Legend has it that Clark Cable and Carol Lombard married in Yuma and then honeymooned at Phoenix's Hotel San Carlos.

Although old Hollywood would touch the town, it would be decades before the next seminal project arrived in Yuma. In 1982, Harrison Ford appeared in the iconic *Star Wars Episode VI: Return of the Jedi*, a film that utilized the Buttercup Valley (part of the Imperial Sand Dunes), located about fifteen minutes from downtown Yuma. The dunes were transformed into the Dune Sea, where Jabba the Hutt imprisoned Han Solo on his sail barge, with Princess Leia, Chewbacca and Luke Skywalker fighting to rescue Han. The lumber used to build the barge was later used in the roof of an adobe home located along West Iron Drive, along with many horse corrals throughout

the city. Many Yuma residents remember fishing for pieces of the set in the Buttercup Valley after filmmaking.

But Yuma's golden era of filmmaking is the late 1980s to the early 1990s, according to Yvonne Taylor, longtime director of the Yuma Film Office. Independent filmmaking increased during this time, bringing filmmakers such as Eric Louzil to town. Taylor found herself lunching with the likes of Mel Brooks and John Candy. During this time, the remake of *The Getaway*, with Alec Baldwin and Kim Basinger, was filmed in Yuma at the historic Hotel Del Sol, Yuma's leading place to spot celebrities in its heyday. Taylor attended a cast party with temperamental actor Baldwin but remembered that he "was so nice, hard to see him having a meltdown at all." A University of Arizona study named 1994's *Stargate* with Kurt Russell and James Spader as the biggest film to hit Yuma. During the making of *Stargate*, producers needed a helicopter to smooth out the dunes for aesthetic reasons, so Taylor called the Marine Corps Air Station, and it obliged in three minutes.

Sometimes, it is not the blockbuster films that elicit the strongest reactions from audiences. In 1995, the crime film *Black Day Blue Night* was certainly an example. Filmed in part at Yuma's old hospital, the film's set decorator had thrown away pictures taken of the set, one of which showed a severed head. The image was found and promptly taken to the police, but it appeared to be so grisly that police would not release it to the media. During the world premiere of the film, held at the historic Yuma Theatre, the same police officers, upon figuring out the true origin of the photograph, laughed riotously at their mistake.

With an intrigue-filled moviemaking history, there is much to experience for any avid film tourist in a town popularly known as the agricultural capital of Arizona. In addition to touring movie locales in the city and outer lying sand dunes, visitors may also catch the annual Yuma Film Festival, celebrating the heritage of the city's filmmaking, as well as student and independent filmmakers. Why not make it a date?

ARIZONA ON THE SMALL SCREEN

The Spirit and Essence of the West

Wallace was a television pioneer. And watching his show was a big part of growing up in Arizona.
—Robin Wilson, lead singer of the Gin Blossoms

Television had been this country's dominant form of media, a nearly continuous presence in virtually every American life since its invention, arguably until the Internet age. During this period, from the 1950s to the early 1970s, western television shows were among the most popular in America, peaking in 1959. Through viewing the western television show's pop culture, audiences around the world were given more opportunities to become exposed to the West than ever before. Although filmed largely in California, some of these early favorites included *The Lone Ranger*, *The Gene Autry Show* and *The Roy Rodgers Show*. Old Tucson Studios hosted most of the western television shooting in the state, most notably an early episode of the *Rawhide* series with then unknown actor Clint Eastwood. Many future movie stars got their start in western television shows, including Burt Reynolds, James Garner and Steve McQueen.

From the '50s through the '70s, several episodes of popular programs such as *Route 66*, *The Fugitive*, *The Virginian*, *Gunsmoke*, *Bonanza* and the series *The High Chaparral* filmed at Old Tucson as well. Created by David Dortort, who had previously created the successful *Bonanza* series for NBC, and set in the Arizona Territory of the 1870s, *The High Chaparral* revolved around a ranch run by John Cannon, played by Leif Erickson, and brother Buck

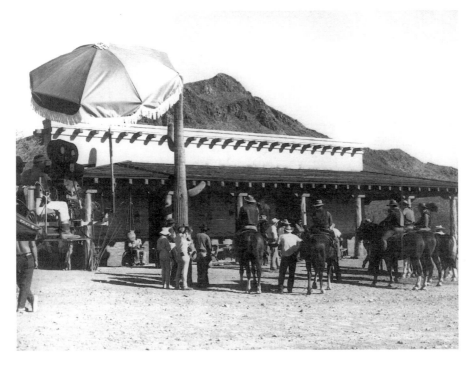

Set in the 1870s, *The High Chaparral* was a popular TV show revolving around a ranch and starring Leif Erickson. *Courtesy of Old Tucson Studios.*

Cannon, played by Cameron Mitchell. An exception to the dominance of westerns is the 1974 detective series *Petrocelli*, a southwestern Colombo starring Barry Newman and Susan Howard that broke the mold by using the urban city setting of Tucson. Other notable television programming included the trailblazing sitcom *The Dick Van Dyke Show* (produced by Carl Reiner) shot in Phoenix in the 1960s, along with *The Wallace and Ladmo Show*, an extremely popular morning show for children, which ran from 1954 to 1989.

Television material grew continuously until it became the prevailing force in southern Arizona filmmaking in the 1980s. During this time also, the rise of the situation comedy caused public interest in western television shows to diminish. One exception was Michael Landon's *Little House on the Prairie*, a hugely successful and long-running western series. Based on the book by Laura Ingalls Wilder, *Little House* chronicled pioneer days on the western grasslands, although it was mainly filmed at Old Tucson Studios. Television

Little House on the Prairie chronicled pioneer days on the western grasslands, although it was filmed mainly at Old Tucson Studios. *Courtesy of Old Tucson Studios.*

Young Guns, with the all-star cast of Charlie Sheen, Emilio Estevez and Keifer Sutherland, also shot at Old Tucson Studios. *Courtesy of Old Tucson Studios.*

at this time was the real "cash cow" for the city of Tucson. "*Little House on the Prairie* injected a huge amount of money into the local economy, with the show's producer and star, Michael Landon, sponsoring many local charity events," remembered film historian Jennifer L. Jenkins.

But the western would have its comeback. In 1989, *The Young Riders* became one of the first weekly westerns on network television since the 1970s, paving the way for film *Young Guns*, with an all-star cast including Charlie Sheen, Emilio Estevez and Keifer Sutherland, also shot at Old Tucson Studios. Other modern western television shows and series—such as *The Magnificent Seven*, which shot its pilot at Mescal studios in southeastern Arizona; the continuation of Aaron Spelling's *Dallas* in 2012 (*Desperate Housewives* on a ranch); and the critical and commercial success of HBO's *Deadwood*—prove that there is staying power for this tumultuous television genre.

Dead Men: The Series is a western television series inspired by the classics *Lonesome Dove*, *Tombstone* and *Unforgiven*, as well as *She Wore a Yellow Ribbon* and John Ford's other work. Filmed on location in rustic Gammons Gulch, just north of Benson, as well as at the Triangle T Ranch in Dragoon, the series is set at a time when a man's word and handshake meant something, according to the show's creators, Ric Maddox and Royston Innes. "The series gives audiences a feel of the authentic West," said Maddox, the multitalented co-creator, writer, actor, producer and founder of Saddlecreek Films. The series is also homage to what producer and co-creator Royston Innes likes to call the "real man." "My partner Ric and I sat down one day talking about how the rugged man, the leading man, isn't being represented anymore in Hollywood. What I hope is that this show brings back the power of the mature man. The man who struggles against adversity and has to make tough choices in difficult situations…No greater genre depicts that than the western."

The series has shot at the Wyatt Earp Theatre and in the town of Tombstone itself, leaving its producers to comment on the authenticity of Arizona's sets. "The history is ingrained in the wood; you can't make that. You can't get an LA set to bring you that." Although producers could film anywhere and receive a considerable tax rebate, when pointedly asked, they thoughtfully respond that "anywhere" would not offer what Arizona can and does. "I love filming in Arizona. I love the people. I love the locations. There's a spirit and a code that fits with *Dead Men*."

MADE FOR TELEVISION

Television movies may lack the glamour of a Hollywood or independent film, but they provide a significant boost to a local economy with their potential to spend a great deal of capital in a short amount of time. Two melodramatic gems to be shot on location in Arizona are 1996's *No One Would Tell*, starring Candace Cameron and Fred Savage and filmed in Phoenix and Mesa's Saguaro Lake, and *An Unfinished Affair*, starring Jennie Garth and filmed at numerous locations throughout Tucson's historic Barrio Viejo. Enduringly popular and entertaining, both television movies are replayed continuously on cable television. Other television movies shot around Tucson in the 1990s include *Desperado*, three separate films for NBC starring Alex McArthur of *Kiss the Girls* and *Geronimo* for Turner Television. In 2007, when Disney's Touchstone Television wanted to turn Stephen King's book *Desperation* into a movie, it utilized unique locations around southern Arizona as stand-ins for Nevada and Asia; Congress Street downtown, which was dressed to resemble Saigon in the 1970s; the Tucson Convention Center, where four interior sets were built; Tucson's Winterhaven neighborhood on East Fort Lowell Road; Old Tucson; and even a mine in Bisbee. Directed by Mick Garris and starring Steven Weber, Annabeth Gish and Ron Perlman, the film premiered at the Fox Tucson Theatre.

REALITY TELEVISION: THE DRAMA OF RISK

Documentary filmmaker Frederick Wiseman was renowned for studies of social and governmental institutions and indirectly influenced the origination of another genre to film across Arizona in recent years: reality television. Since the 1990s, there has been an enormous influx of television programs to hit the network and cable airwaves—MTV's *Real World*, *Survivor*, *Big Brother* and *The Bachelor*—all utilizing the techniques of documentary filmmaking. The nation is now hooked on reality television in all its manifestations for entertainment, drama and escape, and reality TV provides that escape as well as any western, sitcom or television movie.

Indeed, reality TV has been the dominant form of television to film in Arizona in recent years. Reality shows that have filmed in Phoenix include

Extreme Infestation, *The Biggest Loser*, *Mob Wives*, *Candy Girls*, *Job Swap* and *The Bachelorette*, accounting for a significant chunk of the filmmaking that occurs in the city. Filming reality television shows requires less overhead and time than a television movie or series, but as with all filmmaking, "the sanctity of the script is still of the utmost importance," observed Phil Bradstock of the Phoenix Film Office.

Eric Hofstetter worked on *America's Most Wanted* for fifteen years as a location scout and production manager. Whenever there was a local criminal worthy of a story, episodes for the show shot its dramatic reenactments at many Phoenix-based locations, including Mesa, Bartlett Lake and Papago Park for cases such as the Mormon cult leader Warren Jeffs. "A lot of times, people could not distinguish between the actors and their real criminal counterparts," Hofstetter said. "So the FBI had to provide letters to the local police explaining their true identities." In southeastern Arizona, the 2010 episode of *Man vs. Wild* (Sky Island Region) for the Discovery Channel shot in the Sky Islands and Chiricahua Mountains at the historic Kings Anvil Ranch and Texas Canyon. The lights of small-town Benson signified a dramatic reentry into civilization for the show's host. A year later, Tucson saw the filming of episodes of popular reality shows *The Millionaire Matchmaker* and *Real Housewives of New Jersey* at its world-famous Miraval Resort and Spa, showcasing spectacular views of the Catalina Mountains.

Locations chosen by reality shows are often more functional. Hands down, Phoenix's Sky Harbor airport is one of the most popular filming locations in the state for reality television because for reality TV, establishing a location in the first place (where cast members have just arrived or departed) is critical. Filmmaking of the reality kind, whether it is the Discovery Channel, Animal Planet, special subject coverage by A&E or the History Channel, pumps a great deal of money into the local economy; for a recent Italian reality TV series similar to *Survivor*, filmmakers spent several million dollars throughout Tucson and southern Arizona alone.

PHOENIX

Movie Traveler's Delight

> *A man should have a hobby.*
>
> —*Janet Leigh,* Psycho

In the history of Arizona's filmmaking, the city of Phoenix is a late bloomer. But the desert megalopolis has more than caught up. Beginning in the 1950s, when Marilyn Monroe came to town to film *Bus Stop*, Phoenix has transformed itself into a real world-class movie location in its own right. With one of the largest and most diverse populations in the country, Phoenix is a major location for both studio films and independents. The diversity of its locations plays a key role in the city's selection as a site for filmmakers. "For the whole state of Arizona, the geography is amazing for the filmmaking industry," said Phil Bradstock, manager of the Phoenix Film Office. Recently, the Jamie Foxx action-adventure film *The Kingdom* used Phoenix as a double for Saudi Arabia.

With a variety of charismatic locations, permit ease and cooperation from municipal government, the city's proximity to Los Angeles makes it easy and inexpensive for production companies and especially reality shows to pack up a van and head out for a day or more of shooting. With the highly experienced local crew and great winter weather, all kinds of filmmaking are feasible. The city, in turn, generates tax revenue and job creation. "The city of Phoenix is very pro-film," said Bradstock.

Perhaps better known for golf- and spa-related tourist attractions, any visitor and film buff can take in a variety of movie-related locations across

Hollywood's "Golden Age" stars Marilyn Monroe, Ingrid Bergman and Spencer Tracy stayed at the Hotel San Carlos, built in 1928. *Author's collection.*

the sprawling modern capital. Phoenix is a city of abrupt contradictions, with beautiful and futuristic neighborhoods juxtaposed with urban decay. Downtown Phoenix is a lovely area to get a true sense of the city's incredible film history. The ghosts of old Hollywood abound; the original bus terminal in *Bus Stop* was located at the corner of Central and Van Buren in downtown Phoenix. Half a block away stands the historic Hotel San Carlos, where Clark Gable and Carole Lombard honeymooned. Don't miss the Star Walk that frames the hotel and have lunch in the decadent French Café located inside.

Alfred Hitchcock used Phoenix as the setting in his 1960s classic *Psycho*. Serial killer Ed Gein inspired the Robert Bloch novel on which Hitchcock based his screenplay. *Psycho* is the story of a Phoenix secretary who steals $40,000 from her employer's client, flees town with the hope of starting a new life with her lover and checks into a motel run by Norman Bates (Anthony Perkins). The rest is a matter of pop culture history. The opening shot to the classic horror movie, where audiences are first introduced to main character Marion Crane, played by Janet Leigh, was filmed on the Art

The opening shot to *Psycho* was filmed at the Art Deco Orpheum Lofts on West Adams Street in downtown Phoenix. *Author's collection.*

Deco Orpheum Lofts on West Adams Street. As much an exploration of the nature of paranoia and fear as horror flick, the first hour of the film leading up to Marion's murder is pure cinematic magic, with unforgettable dialogue between Leigh's character and Perkins. One of the most talked-about films in history, *Psycho* was also the biggest box office success of Hitchcock's career. Hitchcock even found an office worker in Phoenix who resembled the fictional Marion Crane and photographed her entire wardrobe to get his leading lady's clothes exactly right. During its first run, audience members were required to see the film from the beginning. *Psycho* is widely credited with bringing horror movies to the mainstream—*The Exorcist, Scream* and countless others all owe a debt to this groundbreaking film.

In the 1976 remake of *A Star Is Born* (Judy Garland starred in the original film), Barbra Streisand performed at Tempe-Sun Devil Stadium on the Arizona State University campus. Clint Eastwood filmed part of his 1977 film *The Gauntlet* in downtown Phoenix at the Phoenix Symphony Hall, doubling for the police headquarters in the film. The Phoenix Police

Department resented the corrupt way it was portrayed. As a result, any filming that hoped for the police department to appear on camera had to be approved by the Phoenix Film Office.

Filmmaking has a direct as well as anecdotal influence on tourism in the city. Recently, a popular Japanese travel show filmed Phoenix suburb Cave Creek's annual event the Running of the Bulls. After that episode aired in Japan, Cave Creek and the area saw a boost to its tourism, with visitors showing up in droves. It is still Marilyn Monroe's *Bus Stop* that maintains the strongest influence on the city's film-related tourism, though.

THE NEW WILD WEST

The 1980s brought lighthearted but prominent filmmaking to Phoenix. In 1987, a large amount of filming was done in the city and across the state for the Coen brothers' groundbreaking film *Raising Arizona*, starring Nicolas Cage and Holly Hunter. "Every character, great or small, has the juice of comic originality in him," wrote reviewer Richard Corliss of the film in *Time*. The majority of *Raising Arizona* was shot in Scottsdale, with all of the interior scenes filmed at Southwest Studios, located in Carefree. "The opportunity to work with young rising directorial stars like Ethan and Joel Coen was, well, a real meaningful life experience," said the film's key grip, Mary Miller, who has since worked on films such as *The American President* and *Horrible Bosses*. "I remember there were times when lead actor Nic Cage would make suggestions when he shouldn't be on how things should be shot, and he was always ignored and shot down by the Coens, which would irk Nic," told Mary. Cast and crew would grab a drink at the corner of Lincoln and Scottsdale Roads at the old El Torito Mexican restaurant. "You would have Nic Cage, John Goodman, Will Forsyth, Holly Hunter and Frances McDormand hanging out, still in full wacky character and crazy costume, drinking and whooping it up with us crew folks, and nobody in the restaurant or bar noticing who they were."

Other noteworthy movie locations of this period include Coronado High School, located on Fifty-second Street between McDowell and Van Buren, and the metro center mall seen in *Bill and Ted's Excellent Adventure* that same year. *The Grifters* (1989), with John Cusack and Angelica Houston, was filmed at the Sky Harbor airport and the Turf Paradise racehorse track.

It was the 1990s, however, that put Phoenix and myriad locations on the radar for feature filmmakers. The Phoenix International Raceway was used extensively for the blockbuster car racing film *Days of Thunder*, with Tom Cruise and Nicole Kidman. In 1995, posh suburb Fountain Hills was the setting for *Waiting to Exhale*, staring Whitney Houston and Angela Bassett, along with the Frank Lloyd Wright–inspired Arizona Biltmore Hotel. In 1996, possibly Phoenix's most well-known modern film, *Jerry Maguire*, again featured Tom Cruise, with Cuba Gooding and Renée Zellweger. *Jerry Maguire* used numerous locations—the Sun Devil Stadium, the Cardinals Training Center, Tempe, Apache Junction and Lost Dutchman State Park—throughout the sports-oriented city to great effect. After the film's release, its witty one-liners "You had me at 'Hello'" and "Show me the money" quickly became part of pop culture.

Raising Arizona, Bill and Ted's Excellent Adventure and *Jerry Maguire* set the stage for a new era of filmmaking in Phoenix that transcended the cowboy stereotype in the type of movies that can be filmed in the city. That day has arrived. When Nissan needed a large "'European-style' city for a commercial, they chose Phoenix," commented Bradstock proudly. In the new millennium, Phoenix continues to see more big-budget filmmaking, notably 2008's critically acclaimed film *Jolene*. Based on an E.L. Doctorow short story ("Jolene: A Life"), the film starred Jessica Chastain in her breakthrough role, along with Dermot Mulroney, Denise Richards, Chazz Palminteri, Rupert Friend and Michael Vartan. The story of a teenage orphan who travels cross-country in search of herself, the movie was filmed throughout the state, utilizing the towering Historic First Presbyterian Church on Monroe Street in downtown Phoenix. With more than one hundred rooms, the church was selected as a location because it gave filmmakers the ability to appear in many different places at once, explained Larry Walther, the film's locations manager. *Middle Men*, starring Luke Wilson and chronicling the life of Jack Harris, pioneer of Internet commerce, was also filmed in Phoenix during this period. During the making of the film, the city experienced a heat wave, but extras wore huge jackets as though it were winter, only with nothing underneath.

Clearly, technology will continue to change the way films are made or not made. Digital technology has influenced the explosion of reality television filming over the past decade or so, and Phoenix has benefited. Still, Bradstock pointed out that "what is still critically important is the script. You can have all the explosions in the world, but without a good story, it doesn't have legs to it." Even with the onslaught of technological advances

Filmmaker in Focus: Dustinn Craig

Prominent Mesa-based documentary filmmaker Dustinn Craig has been making films since his teenage years, when his father brought home a VHS camcorder. His documentaries include I Belong to This; Matters of Race, *produced for PBS; and* Creation Story, *for the White Mountain Apache Museum and Cultural Center. Craig particularly loves to film Arizona's White Mountains, his homeland as a White Mountain Apache. In 2005, Craig filmed the half-hour documentary* Home *for the Heard Museum in Phoenix. The film focused on the broad topic of the meaning of home and was the Heard Museum's signature film of the Native Peoples of the Southwest exhibit showcasing the communities of the Pascua Yaqui, Tohono O'odham, Navajo, White Mountain Apache, Taos Pueblo and Jemez Pueblo. "All this time on the road, seeing the Southwest and learning of the distinct cultural differences throughout Arizona and New Mexico, really allowed me to appreciate each unique native culture, language and community…There were larger themes we had in common, but our world views and languages were all so vastly different from one another. This helped me to cherish my own lineage in ways I had not before this project."*

Challenged with communicating a complex experience of native history and culture to a general public, Craig explained that contrary to popular perception, "Native people did not exist in neat vacuums oblivious to the plights of one another." With broad experience as a cameraman, editor and director, Craig's largest film to date is a historical documentary about the life and times of the famous Chiricahua Apache Geronimo for American Experience, *part of a larger five-part series on Native American history called* We Shall Remain, *broadcast nationally on PBS in 2009. Craig is currently working on developing a historical documentary about his own tribe, the White Mountain Apache, and their experience from the arrival of settlers in 1848 to the beginning of the Apache Campaign, as well as their transition into the 1900s. It is a very difficult task because, incredibly, he is finding that "very little is actually written about us."*

Luke Wilson at the Phoenix Film Festival for *Middle Men*. *Courtesy of Phoenix Film Festival.*

across all business sectors, still "movies aren't made on set; they're made on the telephone," he explained. "A lot of the industry is gut instinct." Tony Whitman, a prolific cameraman who has worked on projects such as *Waiting to Exhale*, *Die Hard* and *The Getaway*, compares filmmaking to a cattle drive across country. "After a couple months working the herd, we move on to the next outfit for another run."

THE STUDIOS OF PHOENIX: CUDIA CITY

Before it was a wealthy enclave, Paradise Valley was a wild western movie colony called Cudia City, located at the northwest corner of Camelback Road and Fortieth Street. Its namesake, Italian-born Salvatore Cudia, inherited the title of marquis and, as a young man, deeded his considerable property to an orphanage before immigrating to America in 1904. Cudia worked as an artist in a multitude of fields, ranging from forming an Italian opera company in Washington, D.C., to building movie sound stages in

Florida and Hollywood. Attracted by Phoenix's clear air and cheap land, Cudia moved from Southern California to build his western movie studio eight miles outside the city in 1939, creating the valley's first movie studio. Four films—*Phantom Pinto*, *Buzzie Rides the Range*, *Let Freedom Ring* and *Trail City*—along with *26 Men*, a western series for television, were made at Cudia City before World War II. The TV series *26 Men* drew its title and storyline from the carefully documented exploits of the real twenty-six men who were Arizona Rangers, a group of volunteers founded in 1901 to enforce law in the almost lawless territory.

It was not the war but rather the encroachment of development that halted movie production. The on-site restaurant and accommodations, originally used by film crews, evolved during the war into the Cudia City Guest Resort for visitors wanting to experience a taste of Hollywood. The debonair Cudia attracted Hollywood royalty, including actors Gary Cooper, Tyrone Power and Ginger Rogers and even the king of Iraq, Faisal II. In the early 1960s, Cudia retired at age seventy-four, closing the resort and selling the land for redevelopment. None of the studio buildings was preserved. The marquis spent his final decade living in the nearby Cudia City Estates until he died in 1971 at age eighty-three, leaving behind a son, a granddaughter and six great-grandchildren, although his ashes were never claimed.

APACHELAND MOVIE RANCH: WHERE HISTORY IS FREE

Located near Apache Junction, Apacheland Movie Ranch is a historic studio with a significant but short-lived past as a moviemaking location. Originally intended to be the "Disneyland of the West," a theme park that would also serve as a movie set, the park was designed by Nat Winecoff in 1959, chief visual engineer for Walt Disney during the time when theme parks were really taking off around the country. But in the 1960s, investment disappeared, and Apacheland became solely a movie studio that churned out low-budget movies. Named for the desert previously referred to as "Apacheland" by area ranchers, Apacheland's golden age would be very brief, lasting from 1966 to 1969, although moviemaking there would continue until 1996. Major stars such as Jack Nicholson in the beginning of his film career worked at Apacheland; Elvis Presley would star in 1968's *Charro* as a replacement

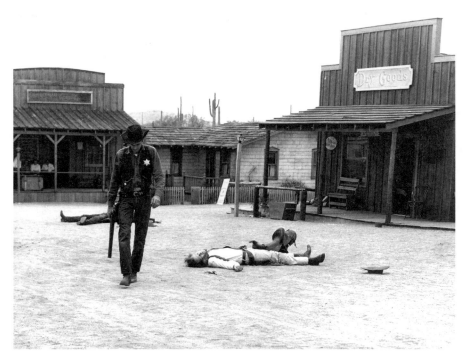

Actor Leland Wainscott walks away from a shootout with the bad guys on the streets of Apacheland. *Courtesy of Phil Rauso, Apacheland Movie Ranch.*

for Clint Eastwood. The film was Presley's last movie and the only film in which he never sang or danced. Famed director Sam Peckinpah made his film favorite *The Ballad of Cable Hogue* at Apacheland in 1970. Apacheland's influence would be long-lasting beyond its days as a movie set. The studio's very existence influenced the development of Apache Junction as a suburb of Phoenix along with a general public awareness of the Superstition Mountains that were featured in many early western television shows.

As the "surrogate parent" of Apacheland and self-appointed historian, Phil Rauso believes in being in the right place at the right time. After a fire at the studio, Rauso realized that the "heart of a community was gone." Restoring Apacheland to its original glory was a hobby that became so much more—the restoration work kept an illness at bay. "Working on Apacheland history keeps my mind off the illness. That's what drives me; it has nothing to do with me but everything to do with what comes after." All that remained of Apacheland were two historic buildings, the

Elvis Chapel and Apacheland Barn, which were moved seven miles north to the Superstition Mountain Museum. Although the original movie ranch's land has been sold, Rauso has plans in the works for building an Apacheland theater to show plays and memorabilia of the glory days of its filmmaking.

SOUTHWEST STUDIOS: IT'S WHO YOU KNOW

Built in 1968, Carefree's Southwestern Studios (also known as Carefree Studios) is most famous for hosting the immensely popular *Dick Van Dyke Show*. With its three soundstages, post-production department, production offices and much more, there was nothing else like it in the state at the time. Van Dyke (*Mary Poppins*), who had moved to a ranch about eight miles from the studio, happened upon the location while riding his dirt bike one day and immediately became interested in filming a show there. Before Van Dyke took the stages over, though, Bob Hope, Orson Welles, Paul Newman

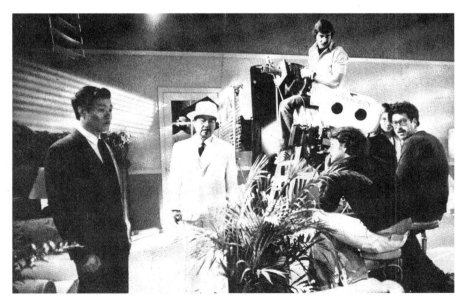

Carefree's state-of-the-art Southwestern Studios hosted the immensely popular *Dick Van Dyke Show. Courtesy of Michael Ohrling.*

Orpheum Theatre: Grande Dame of the Movies

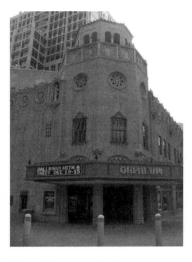

Phoenix's ornate Art Deco
Orpheum Theatre. *Author's collection.*

In 1927, construction began on Phoenix's new Orpheum Theatre, an extravagant Spanish Medieval– and Baroque-style theater originally used for vaudeville shows. The Orpheum is a movie palace that represents an opulent architectural style based on foreign styles where buildings tried to outdo one another to attract audiences. It is the only period movie palace in the Phoenix area to have survived. From 1929 until 1948, the Orpheum's talkies and musical productions entertained the city's residents and provided an escape from the hardships of the Depression and World War II, hosting the likes of Frank Sinatra and Mae West. However, by the late 1940s, new residents had begun to settle in the suburbs of the city, drawing crowds away from the theater. Over time, various owners destroyed much of the Orpheum's intricate painting, covering over its murals to avoid competing for attention with productions.

In the 1960s, James Nedelander brought new life to the theater when it became part of Nedelander's string of playhouses for touring Broadway plays and musical productions, enabling new generations of Phoenicians to see large productions such as Annie, Cabaret and Barefoot in the Park. By 1977, the outdated Orpheum was struggling to compete with Phoenix's thriving suburban theaters that showed widescreen extravaganzas. After it fell into disrepair, the City of Phoenix purchased the theater in 1984. After a twelve-year, $14 million restoration, the Orpheum Theatre's intricate moldings and rich landscape murals were fully restored in 1997. Today, this national landmark regularly hosts musical concerts, speakers, touring Broadway groups, diverse multicultural events and even shows the occasional silent film. Contact: 203 West Adams Street, Phoenix, AZ, 85003, (602) 534-5600, http://orpheumtheatrephx.com.

and other film greats had used its facilities. The unfinished picture *The Other Side of the Wind* (1972) was also filmed at the studio. Cinematic geniuses on the film included John Huston, Peter Bogdanovich, Frank Marshall and Orson Welles. "Contrary to what you've been told, it is who you know in this business," Marshall told the film's movie technician Michael Ohrling memorably one day.

The Zabriskie Point House was also used as a location on the film. The house was used by Michael Antonioni in his film *Zabriskie Point* and became known in the local film community by this name. Cast and crew stayed overnight at the house, and director Orson Welles would wake up at two o'clock in the morning, inspired and ready to get to work. It became very difficult to hire and keep crew because of these eccentricities. Still, the ambitious Ohrling stayed. "You have moments in the business that are real equalizers—at night, these are still regular people even though by day, they are movie gods. At midnight, I was in the kitchen making myself a snack standing next to Edmond O'Brien [Oscar-winning actor for *The Barefoot Contessa*], who was humming a song at the time. I'll never forget it." Following *The Other Side of the Wind*, films such as *Raising Arizona, Bill and Ted's Excellent Adventure* and others used the studio before its eventual sale and demolition in 1999. Sadly, the land was worth much more for residential development.

CHAPTER 8
NORTHERN ARIZONA

Hometown Prescott to Monument Valley

L ocated about one hundred miles north of Phoenix, Prescott is typical northern Arizona—high desert, with a combination of red rock and thick forest scenery. Founded in 1864 as the state's first territorial capital, tourism injects large sums of money into Prescott with its clear, crisp air; the twinkling Cottonwood leaves just starting to change; and the coming fall and summers that draw many travelers up from hotter climates to the south. Prescott is medium-sized in population but with small-town elements, giving it the nickname "everybody's hometown." The town manages to be both liberal and conservative; a gun shop is positioned across the street from the organic farmers' market, but tree-lined residential streets could be anywhere. Prescott's immaculate Victorian architecture, a relic of its gold mining boomtown days, and comfortable seasonal weather make the town a bona fide filmmaking dream location and an inspiration.

Prescott has been a hub of all types of filmmaking. The year of Arizona's statehood, 1912, also initiated the town's considerable filmmaking history. In that year, director-writer and matinee idol Romaine Fielding arrived in Prescott to open a Lubin Film Company studio after a successful run of moviemaking in Tucson. The Lubin company was founded by Siegmund Lubin, a Polish immigrant who operated an optical supply business in Philadelphia. As one of the first to make motion pictures, Lubin used his backyard as a studio, with a dark room in the basement to process film. By 1912, the Lubin company was a major filmmaking power.

Fielding's new location had recently undergone a series of metamorphoses, from major mining center to mountain retreat for tuberculosis sufferers. Tourism promised a bright economic future for Prescott, and by 1912, construction and mapping of passable roads had connected it to the state's newest major cities and scenic areas. The potential of motion pictures to promote the city had not gone unnoticed. Malcolm Frazier, secretary of the Prescott Chamber of Commerce, had contacted Fielding, telling him of the many advantages of filming in Prescott.

Fielding's Lubin company set up an outdoor stage with a sliding canopy for shooting interiors constructed behind the Mercy Hospital. It filmed *The Cringer*, *The Uprising* and *The Forest Ranger* in 1912. The main hospital burned down, but some of the buildings remain and are used by Prescott College. In addition to Mr. Fielding, members of the cast included Robin Adair, second lead and leading cowboy; Richard Wangeman, character stage actor; Mary Ryan, leading lady; George Clancy, in comedy roles; Miss Mason, ingénue, writer and composer; and Mrs. Williamson, character actress.

Fielding was formerly a medical doctor turned actor and director. After two years, he closed his practice and went to New York to perform on stage. Fielding was also a prolific writer; he wrote and produced thirty-one vaudeville and dramatic plays in one year. This was the era of silent pictures. These early short films were sent to Philadelphia for processing, and the subtitles were added at that time. In *The Cringer*, Fielding played the cringer, a dimwitted shepherd goaded by his friends into proving that he was not a coward by stealing a horse and robbing a bank. Scenes in the film included wild horseback riding at Granite Dells, a rocky landscape outside town and a bank robbery filmed on the stage behind the hospital.

Another Lubin picture (or "photoplay") was a reenactment of a Native American attack on the Miller ranch about four miles from town in 1865. The Native Americans in the film were local young men who were promised $2.50 each as extras. When the job was done, they went to Romaine Fielding for their pay. He promised they would get it in a few days. As the days went by with only promises, the boys decided to take action. Every evening at about 7:00 p.m., the boys would knock on Fielding's house on South Alarcon Street. Fielding would find new ways to delay payment. After several days, Fielding had had enough and gave them their money.

The Uprising was filmed at Granite Dells, with some scenes at the studios on Grove Street. The *Prescott Journal-Miner* in 1912 described the cast as a "local constellation of robust chivalry and mountain beauty." The film consisted mainly of an Apache attack on trappers, who eventually drove them off.

Granite Dells, a picturesque collection of rock formations, was a location for countless westerns filmed in Prescott, including the 1925 film *Riders of the Purple Sage*. *Courtesy of Visit Prescott.*

The film was shown at the Elks Theatre, and it drew the largest crowd in the theater's history. Fielding then moved away from westerns and broke new ground with a story about the forest service filmed at Spruce Mountain.

Also in 1912, the Los Angeles–based Western Selig Polyscope Company set up a studio and made largely forgotten silent films such as *The Policeman and the Baby* and *Cupid in the Cow Camp*, starring then unknown actor Tom Mix, in town in nearby Prescott National Forest. Mix was the predecessor to singing cowboys Gene Autry and Roy Rogers and would have a long association with the town, making innovative films such as *Pony Express Rider* and *Riders of the Purple Sage*.

In the winter of 1912, Thomas Persons, an official from the Selig company's headquarters in Chicago, was looking for a good location in the Southwest to make westerns. Recalling that two of his employees had once suggested Prescott, Persons began corresponding with the chamber of commerce. By the first week of January 1913, the sixteen-member company had set up its studio on Western Avenue and included character actors Rex de Rosselli; the company's leading lady, Myrtle Steadman; the stock villain, Lester Cuneo; the leading man and director, William Duncan; and

the second lead, Tom Mix. Memorable local sites captured on film by the company included the Diamond Valley area, Bar Circle A Ranch, Granite Dells and Slaughterhouse Gulch, as well as a two-hundred-year-old maple known locally as the "Hanging Tree," situated at the bottom of the aptly named gulch. Cowboys, Indians, outlaws and movie technicians all utilized this tree over the years in films.

The company's film, *The Sheriff of Yavapai County*, employed the standard western formula of the day—crime followed by pursuit followed by retribution—and capitalized on the appeal of simple suspense and violence. The terrain in the well-received film provided the audience with glimpses of the real West. As the company was working a great distance away from its parent studio, the famed Hooker cattle ranch on Ash Creek was enlisted by way of example as the setting for many of its early Prescott films—more than 1,200 head of Hooker cattle were also enlisted for a stampede finale in the film.

The Western Selig Polyscope Company contributed greatly to the development of the American western. By filming in Prescott, it was one of the first companies to break the longstanding traditions of the stage and bring authenticity to the screen while providing a record of an American era that would soon be over. Film historian Kevin Brownlow wrote, "These early Selig Westerns represent a fortunate historical accident for they were photographed in the heart of the west…when the customs and characters of the old days were still very much in evidence…the background was pure documentary."

Director Cecil B. DeMille also came to town to film his first film and Hollywood's first full-length movie, *The Squaw Man*. In 1913, the film industry was still located primarily in the East. Prescott was suggested to DeMille because of its scenic beauty, the availability of authentic ranches and cowboys and the nearly perfect climate. But DeMille and his production manager pulled into Prescott aboard the Santa Fe railway a few days ahead of their cast and crew, just in time for an awful blizzard—the sort of weather that might delay production indefinitely and conflict with the heat of the storyline. So they continued west.

In later years, big-budget films occasionally featured Prescott locales. In 1945, the Gene Tierney and Cornel Wilde melodrama *Leave Her to Heaven* was shot mainly in nearby Sedona and also utilized a rural swimming pool and pavilion at the Garden of the Gods Resort, which operated in Prescott's Granite Dells from 1922 to 1970.

Grassroots hit *Billy Jack* used Prescott as a location in 1971. The film featured downtown locations such as Dent's Ice Cream Parlor (present-

Tom Mix: King of the Cowboys

Tom Mix was the highest-paid movie star of the 1920s. Born in 1880 in Medix Run, Pennsylvania, Mix was inspired to go west to become a sheriff after seeing a Wild West show. Eventually, he became a top attraction with his roping acts at these same shows; one time, one of the owners was with the Selig Polyscope Company. Mix signed with Selig in 1913 and made films such as Ranch Life in the Great Southwest. *Always the good guy, the most spectacular part of Mix's films was his ability to ride, rope, shoot a gun (with real bullets) and perform daredevil stunts. Mix even trained his own horses, the most famous being Tony, a celebrity in his own right. Mix made movies for many years on a ranch just outside Prescott, the Bar Circle A Ranch, the area now known as Yavapai Hills—as ordinary as any suburb in America. Mix's ranch house and studio is the present-day Yavapai Hills Clubhouse. His fame was worldwide, and Mix continued to make films until 1935. On the verge of staging a movie comeback, Mix was killed in 1940 when his car overturned eighteen miles from Florence, Arizona.*

day Kendall's) and the Courthouse Plaza. The controversial film presented Prescott and citizens in an unflattering light, recalled Parker Anderson, local historian, author and stage performer. "When people saw it, they were very unhappy because locals were depicted as redneck and racist." In contrast, the following year, *Junior Bonner*, starring Steven McQueen and directed by famed western film director Sam Peckinpah, was well received by Prescott locals. Set during Prescott's historic Fourth of July rodeo, McQueen played a former rodeo champion returning to his hometown of Prescott. The film featured the elegant Hassayampa Hotel, as well as the Palace Hotel and Bar, Arizona's most historic saloon. "To this day, Prescott old-timers still have a very soft spot for that movie," said Anderson. The decade proved to be a golden age for filmmaking in Prescott. "In the 1970s, people were absolutely in awe [of the films]," he observed. Other films of this era include *Bless the Beasts and Children* and *Gumball Rally*, a car chase comedy.

In the 1990s, moviemaking in Prescott reached another uptick with the 1994 remake of *The Getaway*. The film starred then Hollywood "It Couple" Kim Basinger and Alec Baldwin. The film also showcased much of Prescott's downtown. Anderson remembered a key scene at the Dinner Bell Café

Prescott's historic Palace Restaurant and Saloon was featured in 1972's *Junior Bonner*. *Author's collection.*

Classic diner and movie location, the Dinner Bell Café. *Author's collection.*

where Alec Baldwin's character was talking on a payphone outside, and the director requested normal pedestrian and customer activity to be seen around him. Parker's reflection can be seen in the window of the restaurant while he was playing a pedestrian crossing the street outside. The tone on set and in town was tense, though, he recalled; one of the crew even gave a newspaper photographer his middle finger as they were snapping pictures during filming. Moviemaking is not always all glamour; it can even be boring, according to Anderson: "In the end, the rewards are great," he said. In the final analysis, the celebrity panache of *The Getaway* added some Hollywood glitz to the classic mountain town of Prescott as the first big-cache picture in years.

ARIZONA'S NEW INDIE MECCA

Although Hollywood filmmaking in Prescott would remain scant, local independent filmmaking flourished in the new millennium. "Independent filmmaking is more personal; local filmmakers know the people, the area and what to expect from them. They also have a greater appreciation for the town because they are [from] around here," said Parker Anderson, writer/actor.

A mix of student, amateur and "pro-am" filmmakers in the Greater Prescott area within towns from Chino Valley to Sedona includes Ken Gregg, Forrest Sandefer, Jerry Chinn, Greg Smolarz, Holly Rillovick, Chad Castigliano, Terri New, Deborah Gallegos and Bryan Matuskey. Prescott sees a fair amount of documentary, contemporary comedy and drama but few period pieces. Ken Gregg, one such prolific local filmmaker of short subjects, was born and bred in Prescott. Gregg's movie *Resuscitate* was shot in Prescott along with another short, *Moving Boxes*. Previously, Gregg studied acting for ten years in Los Angeles. Then he had an opportunity to co-produce an indie feature film, which he also starred in, titled *Yonderville*. He was "instantly bitten by the filmmaker bug." Primarily focused on low-budget independent filmmaking, Gregg is inspired by the vast amount of history that Prescott offers compared to other small towns. "The history speaks visually through the incredibly preserved downtown square and surrounding area, lingering a strong sense of being content. It's a filmmaker's dream here, and I'm taking full advantage of it." Gregg's current project, *Something to Remember*, will

mostly shoot in Prescott, with a few scenes in Phoenix. This will be his first independent feature as both director and producer.

Dead Vote Society, a comedy about zombies demanding the right to vote, was recently made in 2013 by Andrew Johnson-Schmit and Angie Johnson-Schmit. Johnson-Schmit began shooting back in the 1990s in Chicago toward the end of celluloid's use in indie film. The editing and digitization process was then expensive, often heavy and hard to get equipment-wise, as he remembers. So Johnson-Schmit swore off film, moved to Prescott and changed directions. "I decided to make radio-theater for local broadcast. The equipment was so much cheaper, easier to use and get your hands on."

After making radio-theater locally for eight years and with a series of live broadcast local shows on KJZA with scripts set in a small fictional town in northern Arizona called Crest Top, modeled after Prescott, in the end Johnson-Schmit found that he was getting the itch to do "visually creative stuff" again. "My wife, Angie, wanted to partner on making a film, and that intrigued me, having someone to work with, instead of going that lonely-in-a-crowd route that is making a film with yourself as the writer/director/producer," he remembers.

So, he gave filmmaking a second look. Recent technological changes had made the prospect cheaper, easier and much more doable than before. In addition, with eight years' worth of adaptable radio theater scripts, it was "a great place to start anew." Many aspects of the town continue to inspire the Johnson-Schmits. "We have some great settings to work with here—Courthouse Square, the Dells, the Forrest Prescott National Forest, the many historic buildings downtown. In my most recent film, when we needed a polling place set up, I used the pueblo of the Smoki Museum—instantly more interesting. We also shot on the steps of the courthouse, where U.S. presidents and candidates have made speeches since Barry Goldwater. Given that it was a film about zombies wanting the right to vote, that kind of real-life irony was a lovely added bonus."

Through the Prescott Film Festival, the Johnson-Schmits have been exposed to the world of filmmakers from around the country, sharing their stories about getting it done on a shoestring. "We are doing preproduction to fund a comedy web series called 'Zombie Hospital,' a mash-up of hospital soap opera and mad scientist films," he smiled. During 2002 in Prescott, filming took place for an independent film called *Arizona Summer*, starring Morgan Fairchild and Lee Majors and directed by Joey Travolta. In 2008, studio filmmaking would return with *Jolene*, starring Jessica Chastain and Dermot Mulroney and shot for about a week in Prescott on the Courthouse

Prescott Elks Theatre

The balconies at the Prescott Elks Theatre are for being seen. Designed in the New Classical style of the early twentieth century, on February 20, 1905, the then named Elks Opera House held its grand opening with a debut play, Marta of the Lowlands, billed as a "romance of old Spain." In 1916, the silent film era came to Prescott, and D.W. Griffith's controversial film The Birth of a Nation was shown at the Elks, with a small orchestra providing accompanying music. Movies were a mainstay at the Elks through the 1970s; by the 1980s, live performances had even returned to the theater. Listed on the National

Many longtime Prescott locals have fond memories of seeing movies at the Elks Opera House. *Courtesy of Visit Prescott.*

Register of Historic Places, the Elks Opera House Foundation was formed in 2002 by a group of Prescott citizens (with the city continuing its ownership) with the goal of restoring the building to its former glory to serve as a cultural and community meeting place. After much renovation in 2006, "Bill," the elk made of Arizona copper that once adorned the top of the theater from 1905 to 1971, was returned to his original place.

"In its day, the Elks was the entertainment center of the town," said author Parker Anderson of the Elks Opera House. Perhaps this sentiment has been rekindled with the resumption of the full historic name of Elks Opera House. Visitors today are greeted at the door by local volunteers dressed in period costumes. Now the nonprofit theater shows independent films and live performances while serving as a cultural focal point of the community. The theater has appeared in many movies, including the opening scenes in Billy Jack and Zoo Gang. Recently, though, "Prescott Idol" draws the huge crowds. Contact: 117 East Gurley Street, Suite 115, Prescott, AZ, 86303, (928) 777-1366, www.elksoperahouse.com.

Prescott's Courthouse Square was used to great effect in recent hit indie film *Dead Votes Society. Courtesy of Visit Prescott.*

Plaza, Mt. Vernon Street, Prescott Mile High Middle School and Arizona Pioneers' Home (the "loony bin" scene in the film). Although portions of the story took place in South Carolina, Phoenix-based producer and art dealer Riva Yares stated in an interview that Prescott was an obvious choice to shoot with its mountains and greenery. Western superstar Tom Mix must have gazed at and been inspired by these same green hills during the making of his many films.

Although Prescott College is my alma mater, through this book, I experienced this unique hippie western locale anew. Walking down Gurley Street, I happened upon the Dinner Bell Café, with pictures of Gary Sinise and Kim Basinger from *The Getaway*, a busy place that morning, while just a few blocks down the street stood the site of the old Lubin company stage. Between the cold gusts of wind, the remnants of moviemaking history are everywhere.

STARRING SEDONA: SCENERY AND SETTINGS IN COCONINO FOREST COUNTRY

They were most dangerous when they had a camera in their hands. They had a camera in their hands a lot.

—*Wild America*

If Arizona had a supermodel for a town, Sedona would be it. Vast and lush Oak Creek Canyon, striking pink-red rock formations and the sea of emerald countryside surrounding the town of Sedona all showcase some of the most otherworldly natural beauty of the Southwest. Because of this jaw-dropping scenery, film producers chose Sedona as the Hollywood studio location for some of the first silent western movies, beginning in 1923 with *The Call of the Canyon*. Sedona provides a setting for nearly one hundred of Hollywood's most famous westerns, including *California, Broken Arrow* and *3:10 to Yuma*, filmed also at the Triangle T Ranch in Dragoon. The names of its streets are names of movies made in Sedona—*Last Wagon, Johnny Guitar, Fabulous Texan, Flaming Arrow* and more.

The Call of the Canyon is about an East Coast woman who travels to Oak Creek Canyon hoping to surprise her love interest. It was originally conceived as one of three movies adapted from Zane Grey novels to be filmed back to back in Arizona, all with the same cast and director, along with *To the Last Man* and *The Vanishing American*. Zane Grey contributed to the western with such novels as *Riders of the Purple Sage, Under the Tonto Rim, Wild Horse Mesa* and countless others, many of which were made into some of these classic westerns during the talkie era.

Until World War II, Sedona was a small rural community of modest farms, orchards and ranches consisting of one general store, a garage, a post office and a church. "The first movie theater in Sedona was the school gym. A small box on stilts was built at the end of the gym as a projection booth. An old man sold sodas and popcorn. This ended when the school burned to the ground in 1948. Films were shown on weekends for the kids at the school," said Paul Thompson, a local historian who was born on a ranch in

Opposite, top: Since the 1920s, Sedona has provided the setting for nearly one hundred of Hollywood's most famous westerns. *Courtesy of Sedona Heritage Museum.*

Opposite, bottom: The making of *California* in 1946. *Courtesy of Sedona Heritage Museum.*

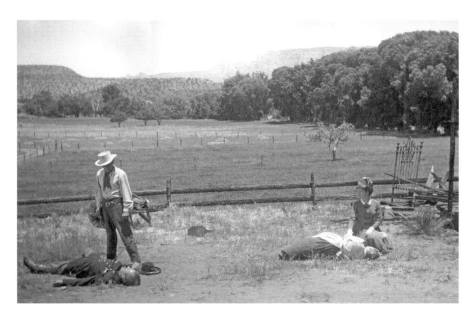

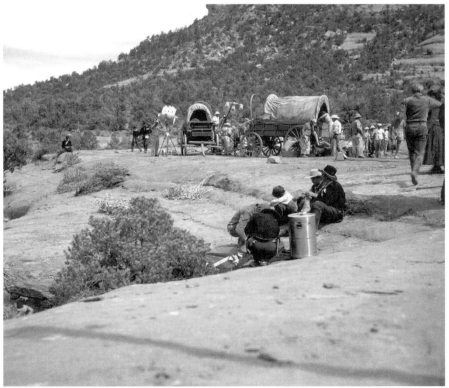

the Sedona area and whose grandfather John J. Thompson was one of the area's first pioneers in 1876.

In Sedona's film history, 1945's *Leave Her to Heaven* was a departure from its western filmmaking heritage. Until this early example of film noir, Sedona's scenery had always been showcased in the context of a western. *Leave Her to Heaven* was a delicious psychological melodrama about a disturbed femme fatale portrayed by the beautiful Gene Tierney. The film was based on a best-selling fiction book of the same name by Ben Ames Williams. The title of the film comes from *Hamlet*, where the ghost of Hamlet's father tells him to leave his mother to heaven for her wicked deeds. Locations in the film include a memorable scene where Gene Tierney spread the ashes of her dead father on spectacular Schnebly Hill. The film was nominated for numerous Oscars, including a nod for Tierney. It was the first psychological drama to be shot in color and is often available free to view by searching online.

Cathedral Rock is perhaps Sedona's most famous rock formation. The iconic geological feature that symbolizes the town has been featured in dozens of movies over the years, including 1947's *Angel and the Badman*, the first film produced by John Wayne, and 1948's *Blood on the Moon*, with Robert Mitchum and Barbara Bel Geddes, who starred in the mega hit 1980s television show *Dallas* as a ranchwoman. The farm set for the film was built in Little Horse Park, what Sedonans know today as the Chapel Area, because the Chapel of the Holy Cross looks out over this area.

Broken Arrow (1950) had film reviewers at the time dusting off their dictionaries in search of compliments. "Too often when the movies adapt a book, the film is paid the left handed compliment 'a good job' but it was not as good as the book," commented one reviewer from the *Arizona Daily Star* in 1950. Based on the book *Blood Brother* by Elliot Arnold of Tucson, then unknowns featured in the film included Jimmy Stewart, who played a real-life ex-soldier who ventured solo into Cochise's stronghold east of Tucson to talk peace with the leader of the Chiricahua Apaches; Jeff Chandler, a former radio actor who played the part of Cochise, the famed Apache leader; and sixteen-year-old Debra Paget. *Broken Arrow* is technically considered a western since it is concerned with the Arizona of years past. With the scenery of Oak Creek Canyon, the story is unique because it was an attempt to depict Native Americans as human beings capable of all human emotions—a call for understanding between two groups of people. The film is also the story of a pact of friendship that grew up between the soldier Tom Jeffords and Cochise, leading to an end to the hostilities between Apaches and white settlers. Stewart's portrayal of Jeffords won praise from those in Tucson who knew the real Jeffords.

Leave Her to Heaven star Gene Tierney, with Cathedral Rock in the distance. *Courtesy of Sedona Heritage Museum.*

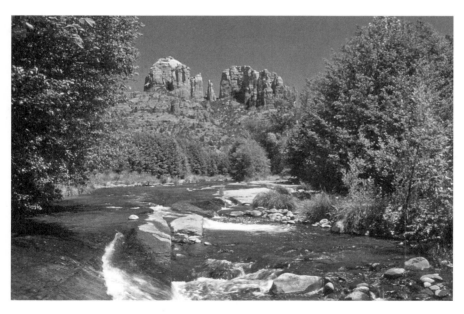

Oak Creek Canyon's iconic beauty has been captured in films such as *Angel and the Badman* and *Broken Arrow*. *Courtesy of Sedona Chamber of Commerce.*

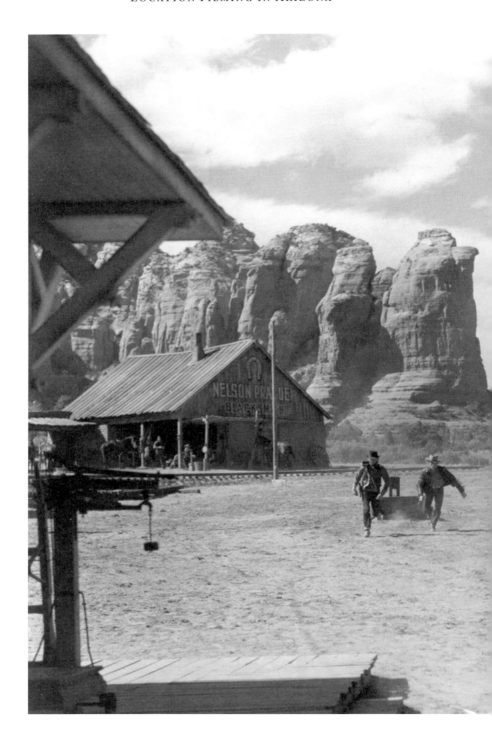

This Sedona
movie set
was built in
1946 and
disassembled
in 1959 when
a subdivision
was built
on the site.
*Courtesy of
Sedona Heritage
Museum.*

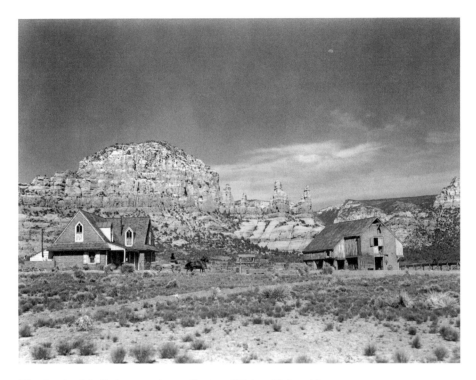

The *Angel and the Badman* movie set. *Courtesy of Sedona Heritage Museum.*

A local girl visiting the movie set built for *Angel and the Badman. Courtesy of Sedona Heritage Museum.*

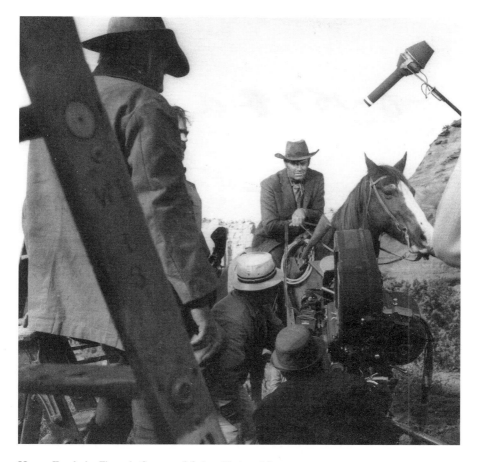

Henry Fonda in *Firecreek. Courtesy of Sedona Heritage Museum.*

By the 1950s, Sedona had begun to grow; increasing numbers of people were relocating to the town, building homes and opening new businesses. The movie industry would have a significant impact on local real estate value as interest in the area grew, fueled by Sedona's beautiful scenery captured in the movies. In fact, Sedona's first licensed realtor, Faye Crenshaw, was a ranch woman who worked for the movies before she began selling real estate. "The overall impact of western filmmaking in Arizona in the mid-twentieth century caused an increase in the residential population and more development, escalating the overall settlement of the state," explained Janeen Trevillyn at the Sedona Heritage Museum.

An "Indian village" movie set for *Comanche Territory* (1950) starring Maureen O'Hara. *Courtesy of Sedona Heritage Museum.*

Elvis Presley in *Stay Away Joe. Courtesy of Sedona Heritage Museum.*

Moviemaking in Sedona brought much-needed cash income to locals, who were no longer able to make a living exclusively from agriculture. Short-term positions in the film industry included work as stunt doubles, riding doubles, extras, carpenters, laborers and wranglers, as well as in wagons and stock rentals, set building, furnishing livestock, cooking, laundry and even boarding stars in private homes. There were also jobs in the service industry at local watering holes like Oak Creek Tavern and Relics Restaurant at Rainbows End (featured in *The Rounders*). Locals and visitors found movie sets to be attractions for exploring and photo opportunities when they were not in use.

Historically, private ranches were often used by the film industry, the most famous of which is Bob Bradshaw's ranch. One of the most influential locals who worked in the movie industry, Bradshaw was one of the first photographers to capture Sedona and worked on many of the movies filmed in the area from the 1940s to the 1970s as an extra, a stand-in and a riding double in nearly every film shot in the area during this time. Many of the significant western films shot in Sedona used the ranch's property and Bradshaw's services, including *Stay Away Joe* with Elvis Presley, who also honeymooned in Sedona while making the film.

MEMORIES OF MOVIEMAKING

"We have two distinct classes here as concerns the attitude of local people toward the movie folks. There are those who are absolutely awestruck by anything connected with the movies. Then there are those who go to the other extreme of looking for only the bad and who try to boost their own ego by saying, 'them big shots don't mean a thing to me.'" So wrote local farm wife and news correspondent Ruth Wool Jordan to the *Arizona Republic* in 1953. Movie production companies were, for the most part, welcomed and well received. Local children were even hired as extras, and many grew up to remember film stars fondly. Joan Crawford, despite her *Mommie Dearest* infamy, was remembered well by Barbara Miller, a local girl who resembled Crawford's daughter, Christina. When Crawford found out it was Barbara's birthday, she intended to give her a twenty-dollar bill but, according to Barbara, reconsidered because it wasn't an appropriate gift for a girl; Barbara received a bottle of perfume instead.

Above: Western television show *Death Valley Days* on a shoot in Sedona. *Courtesy of Sedona Heritage Museum.*

Left: Tyrone Power in *Pony Soldier. Courtesy of Sedona Heritage Museum.*

Opposite: Henry Fonda, honored for making Sedona a star location in the western film *The Rounders. Courtesy of Sedona Heritage Museum.*

"Probably of all the Sedona movies, *Johnny Guitar* [starring Joan Crawford] had the best story line. For a young kid, they were great, and we looked forward to seeing them in the local theater in nearby Clarkdale or Cottonwood," said Thompson. "I played a Cree Indian along with some other kids during the filming of the 1952 movie *Pony Soldier* with Tyrone Power. I did have an opportunity to meet the star [off set] when I was invited to go hiking and on a picnic to explore some prehistoric Indian ruins. I found Tyrone Power to be quite friendly and a nice person. During the filming of the 1962 Disney film *The Legend of Lobo*, a crewmember brought a bear cub used in the film to the local school for children to see, and the cub climbed up the body of the principal, Russell Taylor, to his shoulders."

Interestingly, the name Sedona was not used in any of these early films—those movie cities had always been in Wyoming, New Mexico, Maine, California, Montana or even Canada until the movie that put a correct name to the scenery in the minds of the public: 1965's *The Rounders*. Starring Glenn Ford and Henry Fonda, *The Rounders* is a light, breezy, all-in-good-fun film with stunning Sedona country scenery to boot. In an effort to promote tourism, with *The Rounders*, it was pushed for Sedona to finally receive credit for having some of the most photogenic scenery in the West. Producer Richard Lyons and director-scriptwriter Burt Kennedy eventually conceded, "Why not?" and the name of the town was approved to be used in the film.

SEDONA: THE MOVIE

Just as *The Rounders* is the first film to properly identify the town as Sedona, it wasn't until 2012 that a new film would become the first to be about the town itself: Tommy Stovall's *Sedona: The Movie*, billed as "two inspiring stories of self-discovery [that] intertwine over a day in mystical Sedona." "Although Sedona has a rich moviemaking history with a great number of films shot on location here, there had never been a film actually about Sedona until ours," said Texas-born director and writer Stovall. One of Stovall's goals in making the film was for it to be a marketing piece for Sedona and the state as a whole.

The film's opening scene shows the town's incandescent beauty from a plane's viewpoint flying low. *Sedona: The Movie* is also the first feature film to be completely shot in town since the early '70s, the tail end of Sedona's moviemaking heyday. "Sedona is known for its red rocks and breathtaking beauty, and I knew visually it would make an incredible backdrop for a film. After moving here in 2002, I discovered that Sedona also has a lot of unique, quirky and interesting people, and I felt that many of them would make great characters in a movie," remembered Stovall. "I was a big fan of the TV series *Northern Exposure*, and it was the initial inspiration I used as a model." One of the other story lines of the film involves a gay couple with kids, although "their being gay has nothing to do with the story and is never addressed in the entire film. To my knowledge, ours is the first film to ever do that on such a scale," said director Stovall. Stovall did most of the casting himself and thanks Facebook for letting him get both Beth Grant and Frances Fisher, who famously played Ruth DeWitt Bukater, Kate Winslet's

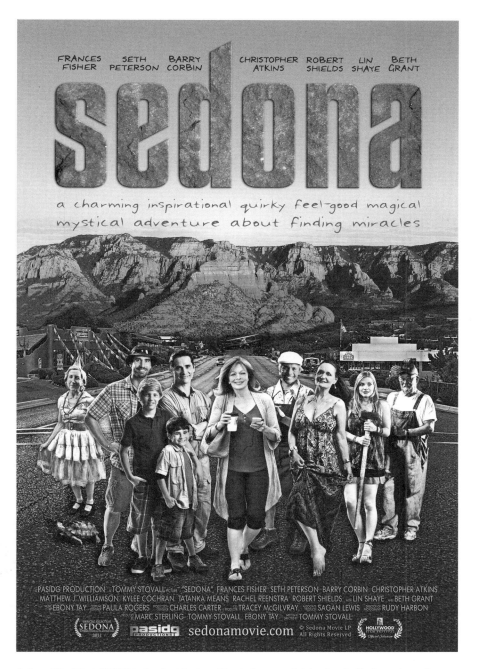

Sedona: The Movie (2012) is the first feature film to be completely shot in Sedona since the early 1970s. *Courtesy of Tommy Stovall.*

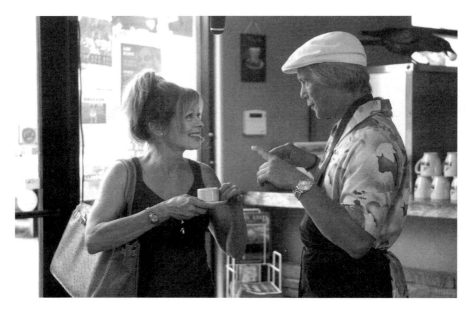

Tammy (Frances Fisher) and Pierce (Christopher Atkins) in *Sedona: The Movie. Courtesy of Tommy Stovall.*

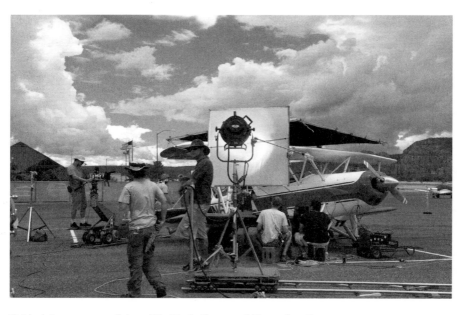

Behind the scenes on *Sedona: The Movie. Courtesy of Tommy Stovall.*

The enchanting film *Sedona: The Movie* "captures the essence of what Sedona is to a lot of people," said its director, Tommy Stovall. *Courtesy of Tommy Stovall.*

character's mother in *Titanic*. "It was Beth who suggested Frances, who is a friend of hers." Stovall would love to keep making movies in Arizona and hopes produce a drama called *Love in a Box*, about an eleven-year old gifted boy who moves in next door to a man with Asperger syndrome. "We'd also like to someday turn Sedona into a TV series because there are so many more characters to explore and stories to tell."

FLAGSTAFF: THE AMERICAN ROAD MOVIE IN ARIZONA

You know, this used to be a helluva good country. I can't understand what's gone wrong with it.

—*Jack Nicholson,* Easy Rider

Beneath the San Francisco Peaks, about thirty miles north of Sedona, sits the Arizona mountain town of Flagstaff. The town is multicultural, artsy

Flagstaff's snow-capped San Francisco Peaks exemplify the scenic beauty that has drawn movie makers here since the early twentieth century. *Courtesy of Ann Haver-Allen.*

and youthful. Although Flagstaff appears to be an isolated community, with the world's largest unbroken forest of ponderosa pines surrounding, it is an easy day trip from Phoenix. With its characteristic northern Arizona seasonal climate, pioneering historic charm and scenic beauty, Flagstaff has attracted filmmakers since the early twentieth century. Although Flagstaff has seen a slightly smaller proportion of filmmaking than other parts of the state, the films that have been made here are nothing less than monumental. In 1919, *Hearts and Saddles* starring Tom Mix was shot at Lake Mary. Incredibly, several of the indoor nightclub scenes for 1942 classic *Casablanca* were filmed not in Morocco but at the charismatic Hotel Monte Vista, a reputedly haunted fixture in downtown Flagstaff. Born through initial investments by prominent local citizens and funds donated by famed western novelist Zane Grey, the Monte Vista, meaning "mountain view" in Spanish, has been in operation since 1926. During the 1940s and 1950s, more than one hundred movies were filmed in and around northern Arizona, and the top-notch accommodation of

ORPHEUM THEATRE

Originally named the Majestic, Flagstaff's Orpheum Theatre was built in 1911 by hotelier John Weatherford as an old movie house. "Historically, the place was the only venue where anything was happening," said current owner and operator Chris Scully. In late 2002, the theater underwent extensive renovations. Today, the landmark theater serves as one of the main entertainment venues in Flagstaff; it is the "center and heart of its community." Unlike large multiplexes, the Orpheum is a classic one-screen theater with a strong connection to the

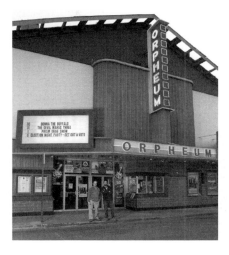

The Orpheum Theatre in Flagstaff.
Courtesy of Chris Scully.

local film industry. No other theater in the state shows films with the same regularity. Notable events include the Flagstaff Mountain Film Festival, as well as other local and national artist events. Owning the theater has allowed Scully, a self-described "music guy," to work with many of his icons and heroes from childhood. The Orpheum's multitude of sell-out shows and innovative events, such as the Adult Prom (the "prom you never had"), have pulled in nearly one thousand people per year over the last fifteen years. Contact: 15 West Aspen Avenue, Flagstaff, AZ, 86001, (928) 556-1580, www.orpheumpresents.com.

the Monte Vista has hosted Hollywood stars since those early years, including Bing Crosby, John Wayne, Jane Russell, Spencer Tracey, Michael J. Fox and Anthony Hopkins. During the making of *Casablanca*, Humphrey Bogart stayed at the hotel.

But the town's location filmmaking came into its own with 1968's antiestablishment road movie *Easy Rider*, the story of two West Coast

counterculture motorcyclists, played by Dennis Hopper and Peter Fonda, hitting the road in search of the American dream. Setting out to reach Mardi Gras, the pair embraces America's wide-open landscapes, finding hippie harmony as well as much hatred and intolerance. The motorcycle riding scenes in the film were shot on stretches of U.S. 89 north and south of Flagstaff.

A portrait of a changing America, *Easy Rider* is a stellar example of the American road movie, greatly influenced by Jack Kerouac's Beat Generation novel *On the Road*. A type of cinema synonymous with American culture, all road movies share two common elements: a road and a reason for traveling it—escape, adventure and self-discovery. Variations exist in all genres. Although personal enlightenment is a theme in any successful road movie, these films are frequently just as much about whom one travels with as the places encountered along the way.

The road movie has the ability to showcase all that is glorious about Arizona. Classic westerns such as *The Searchers* can be considered a type of road movie, along with more modern-day examples like *Natural Born Killers*, filmed in towns across northern Arizona. The theme of a transformational road trip would continue with filmmaking in the area during the 1990s. Several of the running scenes in 1994's *Forrest Gump* were filmed in and around the area, including a memorable scene where Forrest is seen jogging near the Twin Arrow Trading Post, a classic truck stop/curio store/diner combination that stands twenty miles east of Flagstaff along Route 66. The trading post's namesake projectiles appear in the background; now long closed. Parts of the 2007 Academy Award–winning road movie *Little Miss Sunshine*, starring Greg Kinnear and Toni Collette, were filmed in the vicinity of Flagstaff.

The Grand Canyon

No road trip around the state of Arizona would be complete without seeing the Grand Canyon, a major tourist attraction and movie location roughly three hours from gateway town Flagstaff. With a history as a filmmaking destination predating Flagstaff's by roughly twenty years, the larger-than-life canyon has hosted some of Arizona's earliest filmmaking.

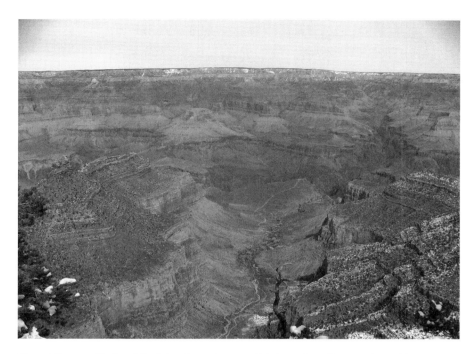

Grand Canyon National Park has hosted some of Arizona's earliest movie-making.
Author's collection.

The first motion picture to be filmed in the canyon was a 1903 short film called *Down the Bright Angel Trail*, made by the American Mutoscope and Biograph Company. Then, a 1912 documentary called *Through the Grand Canyon from Wyoming to Mexico* was shot by pioneering still photographers Ellsworth and Emery Kolb. The first use of the canyon in a western was the Lubin company's *The Great Divide* in 1915, followed by Tom Mix's *Sky High* in 1922. As one of the most visited Natural Wonders of the World, the Grand Canyon has also been featured as a location in the American road movie, including *National Lampoon's Vacation* in 1983 and director Lawrence Kasdan's (*The Big Chill*) 1992 film *Grand Canyon*, in which an all-star cast of characters played by Danny Glover, Kevin Kline, Steve Martin, Mary McDonnell, Mary-Louise Parker and Alfre Woodard visit the Grand Canyon together in the film's climactic scene.

MONUMENT VALLEY: WHERE GOD PUT THE WEST

Most of the good things in pictures happen by accident.

—*John Ford*

Monument Valley is deceptively large. Actually, one could never get lost there. One of the most photogenic parts of the West, Monument Valley is located on the land of the sovereign Navajo Nation on the Arizona-Utah border, the most visited corner of the Navajo reservation. The valley contains some of the most scenic and recognizable vistas in the United States. Monument Valley is not a national park like the Grand Canyon but rather is one of six Navajo-owned tribal parks.

In this vast and vibrant expanse of high desert and towering monoliths, a creative director could never shoot the same thing twice. The first director to use the area was George B. Seitz, who made *The Vanishing American*, a film about the issues afflicting Native Americans, in 1926 among its majestic mesas. Monument Valley really became a mythical movie location when John Ford used not only the scenery of the park but also the surrounding area—including the historic Goulding's Trading Post—in many of his films.

Ford began directing in 1917, starting with short, two-reel silent westerns and then moving on to acclaimed works such as *The Iron Horse* and *The Informer*. At forty-four, he was at the highpoint of his profession, among the five highest-paid directors in the country. But his greatest work and greatest cinematic discovery was still to come. In 1939, *Stagecoach* became the first of seven films that Ford made in the valley with then B-list actor John Wayne. Having heard that an important western was in the planning stages, Monument Valley traders Harry and Leone (nicknamed "Mike") Goulding made a trip to Los Angeles in 1938 with photographs of the valley's formations. Realizing that there would be fewer opportunities for studio interference in this remote location, Ford acquiesced.

The stagecoach in the story carried a drunken doctor, a prostitute, a shady banker and other characters on their perilous journey to Lordsburg through Apache territory. "Never before had a Western looked so western, and by extension, so distinctly American," wrote *New York Times* film critic Frank S. Nugent in his review on March 3, 1939. It was the critical acclaim given to Ford's *Stagecoach* that would solidify Hollywood's new attitude toward westerns. *Stagecoach* won two Academy Awards and made Wayne

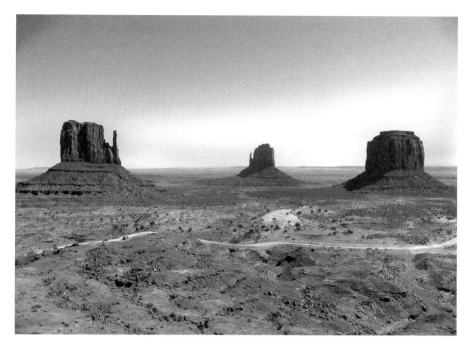

Monument Valley has become a mythical movie location ever since John Ford used its otherwordly scenery in 1939's *Stagecoach*. *Author's collection*.

a star; it also made the western a respected film genre geared toward adult audiences. Since that pivotal year in film history, the area has been a popular site for filmmakers.

John Ford went on to shoot six more westerns in Monument Valley: *My Darling Clementine* (1946), *Fort Apache* (1948), *She Wore a Yellow Ribbon* (1949), *The Searchers* (1956), *Sergeant Rutledge* (1960) and *Cheyenne Autumn* (1964). In addition to introducing the valley's spectacular scenery to an international audience, each film acted as a stimulant for the local economy. The Navajos had great respect for John Ford and presented him with buckskin blessed by a Navajo chief, and it remained one of his most personal belongings.

Greeted as a worthy successor to *Stagecoach*, during the shooting of the 1954 film *My Darling Clementine*, eighty people stayed in the red-rock buildings at Goulding's Trading Post, including Ford and his stars. The story takes place in and around Tombstone, Arizona, actually some five hundred miles to the south of Monument Valley. The picture starred Henry Fonda as Wyatt Earp, Victor Mature as Doc Holliday and Linda Darnell as

Doc's Mexican girlfriend, with Walter Brennan playing Old Man Clanton. Ford enjoyed working with Henry Fonda because the director could hold a camera on Fonda's expressive eyes, and although the actor's face did not move, audiences knew what he was thinking. One rainy day, everyone had a square dance to pass the time on set. This particular scene wasn't supposed to be in the film, but Ford reportedly liked the way the "old-timers" played the fiddle, said Scott Laws, current manager at Goulding's Lodge. Laws's grandfather Wilbur Laws appeared as an extra in *She Wore a Yellow Ribbon*, and his great-grandfather Philip Hurst was an extra in *My Darling Clementine*.

The influence of another John Ford film hit, *The Searchers* (1956), has been even more widespread. *The Searchers* was John Wayne's favorite Ford film. In the film, Wayne plays an ex-Confederate soldier seeking his niece, played by Natalie Wood, who had been kidnapped by Comanches. The film showcases Ford's great ability to break tension with humor while capturing some of the most spectacular western scenery ever seen on film. *The Searchers* inspired the hit song "That'll Be the Day," written by Buddy Holly and Jerry Allison, a catchphrase used by John Wayne throughout the film. *The Searchers* was named the greatest western of all time by the American Film Institute in 2008.

One of the most significant American directors, Ford influenced a range of cinematic disciples, including Steven Spielberg, George Lucas and Orson Welles. Before making *Citizen Kane*, Welles watched *Stagecoach* repeatedly, and when asked to name his favorite director, he reportedly answered, "John Ford."

Ford modestly wanted to be remembered as a guy who made westerns. Today, in Monument Valley, popularly known as "John Ford country," Ford's movies continue to entertain audiences at home and at Goulding's Lodge (started in about 1945), located about six miles from the Monument Valley Navajo Tribal Park Visitor Center. Not far from the lodge is Goulding's original trading post, now a museum.

Monument Valley is not only for westerns, though; the location has also appeared in science fiction flicks, contemporary action movies and even comedies. In *Easy Rider*, Billy (Dennis Hopper) and Wyatt (Peter Fonda) cruise into Monument Valley at dusk, and in Stanley Kubrick's *2001: A Space Odyssey*, also filmed in 1968, shots of Monument Valley were used to create an otherworldly, extraterrestrial landscape. The locations manager for *Back to the Future Part III* (1989), with Michael J. Fox, commented that he never considered any other state when looking for a place to film an Old West scene—he went straight to Monument Valley. In the 1990s, there was a jump in film production on the reservation due to the increased and

renewed popularity of westerns with the success of *Dances with Wolves* and *Unforgiven*. In *Forrest Gump*, the titular character ceases his three-year coast-to-coast run in Monument Valley, to the consternation of his band of followers. In 2013, the controversial film *The Lone Ranger*, starring Johnny Depp as Native American character Tonto, was shot in Monument Valley, and Vic Armstrong will be directing *Comanche Stallion* (Ford's last project though he died before it could be completed) at Monument Valley.

This largely inaccessible, peaceful and stunning wilderness will no doubt continue to inspire new generations of filmmakers of all genres.

ARIZONA'S BEST DESTINATION FILM FESTIVALS

F ilm festivals are a trendy way to take advantage of a locale while catching some great, thought-provoking flicks, mingling with local filmmakers and supporting the local arts community. With their commitment to a multitude of community partnerships and school and student programs, these events are truly the state's best in their ability to exemplify all that is festive and fabulous about Arizona's local and international film community.

ARIZONA INTERNATIONAL FILM FESTIVAL

Since its beginnings in 1990, the Arizona International Film Festival has showcased and celebrated the best in independent film, with Sundance winners, documentaries and independent cinema. The ten-day festival has exhibited more than 2,260 films representing ninety countries to more than 138,000 film lovers in communities across the state. Tucson's nonprofit Loft Cinema serves as a screening venue, as do local historical sites the Rialto Theatre, the Fox Tucson Theatre and the Hotel Congress along with the Screening Room. Local filmmakers have premiered at the festival to sold-out houses. The festival has put Mexican cinema, independent filmmakers and indigenous and experimental cinema at the forefront of the event, with an emphasis on Chicano, Latin American and border issues in cinema, as well as

broader international and political issues. The Festival in the Schools (FITS) program introduces students to independent filmmaking and continues to increase its impact each year. Contact: http://filmfestivalarizona.com.

TUCSON CINE MEXICO

As one of the signature programs of the Hanson Film Institute at the University of Arizona, Tucson Cine Mexico is *the* up-and-coming film festival in the country, celebrating the best of contemporary Mexican cinema. As the first film festival outside Mexico with this mission, Tucson Cine Mexico promotes new generations of Mexican filmmakers who are redefining and challenging traditional notions of Mexican culture as shown on film. The festival is free and open to the public; Spanish-language skills are not required, as films are shown with subtitles. "We really bring in first-

Yulene Olaizola, Elena Fortes, Viviana Besne, Trisha Ziff and Carlos Gutierrez at the "Directed by Women" panel during the 2012 Tucson Cine Mexico. *Courtesy of Tucson Cine Mexico.*

class films, films not often picked up for distribution; it's really one of the few opportunities for filmmakers to get these films seen," noted festival director Victoria Westover. Special guests at the festival have included Carlos Bolado, Oscar-nominated documentary filmmaker of *Promises*, and Carmen Beato, a prominent Mexican film and television actress. Contact: (520) 626-9825, www.tucsoncinemexico.org.

Santa Cruz County Historic Film Festival

Southern Arizona's newest film festival, the Santa Cruz Historic Film Festival, part of the larger Santa Cruz Nature and Heritage Festival, is an educational tourism experience highlighting Santa Cruz County and Sonora's natural beauty, history, heritage and culture. "The work on the riparian area known as Las Lagunas de Anza in Nogales, Arizona, was the inspiration for the festival," said its founder, Linda Rushton. "There were so many birds coming to the site once it was partially cleared, I saw the potential for a birding festival, which then turned into a nature and heritage festival." Drawing from more than 126 movies filmed in Santa Cruz County since the early twentieth century, every movie screened at the festival was filmed in Santa Cruz County, such as *In Old Arizona* (1928), the first talkie western, and *Oklahoma!* (1955), which was filmed in the San Rafael ranchlands. Film festival participants can attend classes on current events, history and nature and tours throughout Santa Cruz County to filming locations and northern Sonora. Now an annual event and community effort, Rushton's goal is to grow both festivals and bring more tourism to Santa Cruz County and northern Sonora. "The border area is a great area to celebrate nature and heritage. We intend to promote the area throughout the world," she said. Contact: (520) 988-5425, www.santacruznatureheritage.org.

The Phoenix Film Festival

Named one of the "25 Coolest Film Festivals" by *MovieMaker* magazine, the Phoenix Film Festival is a program of the nonprofit Phoenix Film Foundation.

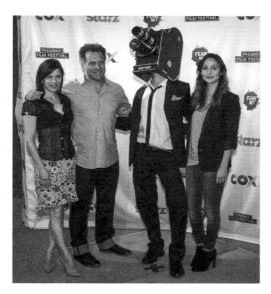

Melora Walters, Doug Dearth, "Camerahead" and Natalie Imbruglia. *Courtesy of Phoenix Film Festival.*

The festival was created by and for independent filmmakers to celebrate the art of film, with more than one hundred filmmakers presenting their films. As Arizona's largest film festival, the event annually screens more than 140 films at the Harkins Scottsdale/101, where festivities, celebrity guests, workshops, filmmaking seminars and glamorous parties are also held over an eight-day period. "No other festival in the country of this size is able to do that, and we're proud of the festival village environment we create year after year," said Jason Carney, president. The festival impressively supports its local community through various initiatives, including the Arizona Filmmaker of the Year award given to a filmmaker who has contributed to the community. On the Saturday night of the festival, a theater is dedicated to filmmakers who are currently in Arizona or native Arizonans. "It's unusual to find a festival of our size that dedicates so much to its local filmmakers." Contact: (602) 955-6444, www.phoenixfilmfestival.com.

PRESCOTT FILM FESTIVAL

The Prescott Film Festival brings "movies that move you" to audiences. "The films we present have strong emotional ties—whether [audiences] laugh, cry or leave determined to change the world," said Helen Stephenson, executive director of the festival. Prescott Film Festival is a destination festival because of the town's natural beauty; audience members can enjoy hiking, golf, canoeing, the historic downtown and the sculpture and art gallery at Yavapai College in between films. This all-volunteer community group has built a "strong local following, which is the base of any film

festival's success," while "building more fans from around the state." The festival seeks out unique indie films to present year round. Studio films are shown during an "Academy Awards® Month" in February that ends with "An Evening at the Academy Awards®'" at the Yavapai College Performing Arts Center. The festival demonstrates to local audiences that "indie films are much more than bad home movies shot in someone's backyard with a bottle of ketchup as the main makeup component," remarked Helen. "We had a very difficult task before us, but we feel we are now established, and people are planning their vacations around our dates." The festival plans to bring Filmmaker Boot Camp for high school students and continue to create a fabulous ambiance for filmmakers and audiences to interact, learn, grow, be moved and be motivated by film. Contact: (928) 458-7209, www.prescottfilmfestival.com.

SEDONA INTERNATIONAL FILM FESTIVAL

One of America's oldest and most glamorous regional festivals, the Sedona International Film Festival gives audiences, movie buffs, industry professionals and the next generation of filmmakers from all over the world a chance to come together to participate in a festival that celebrates the power of independent film. In what could also be considered a destination festival, Sedona benefits economically throughout the entire week of the festival's duration. This is Arizona's most star-studded event, with guests and honorees including Michael Moore, Jerry Stiller, Jane Seymour, Peter Fonda, Nick Nolte, Andrew McCarthy, Linda Gray, Ted Danson and Scott Baio. The festival's unique tribute to "Women in Film" has honored Mary Stuart Masterson and Diane Ladd. The festival features a Classics Series hosted by Turner Classic Movies' Robert Osborne, while its Frank Warner Workshop gives students of film the opportunity to work closely with icons in the industry. A highly prestigious event, films that have screened at the Sedona International Film Festival frequently go on to win Academy Award nominations as well as national box office success. Contact: (928) 282-1177, www.sedonafilmfestival.org.

FLAGSTAFF MOUNTAIN FILM FESTIVAL

The Flagstaff Mountain Film Festival was created in 2003 to provide a cultural alternative to the mainstream commercial film experience and to show a collection of mainly documentary films from around the world to educate, entertain and inspire audiences. "It is really meant as a festival to bring to light certain issues and get you to act upon them," says festival director Ron Tuckman. Remaining a volunteer-run effort, with any profits from the event being reinvested into future festivals, the festival funds an Emerging Filmmaker Program and local charities. Several programs focus on the youth of the northern Arizona local community and surrounding Native American youth. Every year, the Student Program showcases a series of educational and inspirational films for as many as 1,600 local middle and high school students; a traveling version of the program brings it to students at nearby Hopi and Navajo reservations. An Emerging Filmmaker Program provides a free after-school experience in which students learn the fundamentals of documentary filmmaking. Contact: (928) 600-6572, www. flagstaffmountainfilms.org.

AFTERWORD

M ovies have the potential to affect the economy of a place in many positive and long-lasting ways through job creation and tourism promotion. Indeed, the Arizona Department of Tourism cannot print enough brochures promoting Arizona's natural beauty in the way a midsize motion picture can promote the state in just a few showings across the country. However, the future of filmmaking in the state may be very limited as the result of the broader changes the film business has undergone in the last ten years. "With the writer's strike that shut down Hollywood in 2007 and the effects it had on television, in Hollywood and across the nation, producers today are using state tax incentives to pay for the production of a film," actor Marty Miller explained. "Even if the script calls for an Arizona-type scenic desert, filmmakers will just fake it." The 2012 film *Game Change* used New Mexico instead of Sedona to double for John McCain's home. "Producers will often just rewrite the script to fit the most profitable location."

Since the demolition of Southwest Studios in 1999, Arizona has lacked a fully equipped indoor soundstage, a key structure and significant deficiency given the extreme climatic fluctuations in the state and the needs of large film studios. "The industry knew that if you wanted to attract Los Angeles, you'd need a stage complex. For over forty years, Phoenix and investors have overlooked this simple equation," commented Michael Ohrling of COX Creative Studios.

The whims of politicians also play a role. Since the millennium, the state legislature's attitude toward the movie industry has steadily worsened. Many

professionals in the industry predict that the majority of film business will go to Louisiana or New Mexico in the coming years. "There has emerged hostility to film production that is incomprehensible," offered Dr. Jennifer Jenkins. "New Mexico is booming, while our legislature wrings their hands about tax credits. It's incredibly short-sighted and self-destructive." However, some feel that it will take more than tax breaks to replace what once was. "It took years to build the contacts Bob and Jane Shelton had in Hollywood. It also took years to build the support of the folks whose names you see in those final credits. One big selling point was if you came here, you didn't have to bring a lot of people with you; you could hire locals. That talent pool is no longer present, and its usefulness applied to more than just westerns," said Emil Franzi, host of popular radio show *Voices of the West*.

Tax incentives often only benefit big-budget productions and do not affect smaller, independent films, and many local filmmakers want to make films using local subjects and scenery. With its well-preserved historic barrios, Tucson in particular is "a natural for Latino-related films," noted locations manager Timothy Flood, who predicts a solid future in this genre.

At its core, the desire to make movies comes from a desire to tell stories. With recent technological advances, there are even greater and wilder possibilities toward this end. The Internet with all its accoutrements allows a greater number of people to express themselves creatively and make money in the process. Perhaps this innovative era will enable a new generation of filmmakers to harness all that Arizona has to offer.

FILMOGRAPHY

Movies

1910

The Renunciation
Director: Wilbert Melville
Stars: Florence Turner
Local Locations: San Xavier del Bac Mission

1911

The Mission in the Desert
Director: Frank Beal
Stars: Harry A. Pollard, Margarita Fischer
Local Locations: Tucson

1912

The Cringer
Director: Romaine Fielding
Stars: Romaine Fielding, George Clancey
Local Locations: Prescott

1914

The Caballero's Way
Director: Webster Cullison
Stars: William R. Dunn, Jack W. Johnston, Edna Payne
Local Locations: Tucson

1917

The Honor System
Director: Raoul Walsh
Stars: Milton Sills, Cora Drew, James A. Marcus
Local Locations: Yuma Territorial Prison

1921

Three Sevens
Director: Chester Bennett
Stars: Antonio Moreno, Jean Calhoun, Emmett King
Local Locations: Arizona State Prison (Florence)

1924

The Mine with the Iron Door
Director: Sam Wood
Stars: Pat O'Malley, Dorothy Mackaill, Raymond Hatton
Local Locations: Oracle, Rancho Linda Vista

1925

Riders of the Purple Sage
Director: Lynn Reynolds
Stars: Tom Mix, Beatrice Burnham, Arthur Morrison
Local Locations: Sedona, Prescott

The Vanishing American
Director: George B. Seitz
Stars: Richard Dix, Lois Wilson, Noah Beery
Local Locations: Monument Valley

1928

In Old Arizona
Director: Irving Cummings
Stars: Warner Baxter, Edmund Lowe, Dorothy Burgess
Local Locations: Santa Cruz County, Grand Canyon National Park

1936

The Gay Desperado
Director: Rouben Mamoulian
Stars: Nino Martini, Ida Lupino, Leo Carrillo
Local Locations: Downtown Tucson

1939

Stagecoach
Director: John Ford
Stars: John Wayne, Claire Trevor, Andy Devine
Local Locations: Monument Valley

1940

The Westerner
Director: William Wyler
Stars: Gary Cooper, Walter Brennan, Doris Davenport
Local Locations: Tucson

1942

Casablanca
Director: Michael Curtiz
Stars: Humphrey Bogart, Ingrid Bergman, Paul Henreid
Local Locations: Flagstaff

1943

Sahara
Director: Zoltan Korda
Stars: Humphrey Bogart, Bruce Bennett, J. Carrol Naish
Local Locations: Yuma

1945

Leave Her to Heaven
Director: John M. Stahl
Starring: Gene Tierney, Cornel Wilde, Jeanne Crain, Vincent Price

1946

My Darling Clementine
Director: John Ford
Stars: Henry Fonda, Linda Darnell, Victor Mature
Local Locations: Monument Valley

Duel in the Sun
Director: King Vidor
Stars: Jennifer Jones, Joseph Cotten, Gregory Peck
Locations: Empire Ranch, Yuma

1947

Angel and the Badman
Director: James Edward Grant
Stars: John Wayne, Gail Russell, Harry Carey
Local Locations: Sedona

California
Director: John Farrow
Stars: Barbara Stanwyck, Ray Milland, Barry Fitzgerald
Local Locations: Sedona

1948

Blood on the Moon
Director: Robert Wise
Stars: Robert Mitchum, Barbara Bel Geddes, Robert Preston
Local Locations: Sedona

Red River
Directors: Howard Hawks, Arthur Rosson
Stars: John Wayne, Montgomery Clift
Local Locations: Rain Valley, Empire Ranch

1950

Broken Arrow
Director: Delmer Daves
Stars: James Stewart, Jeff Chandler, Debra Paget
Local Locations: Sedona

Comanche Territory
Director: George Sherman
Stars: Maureen O'Hara, Macdonald Carey
Local Locations: Sedona

Winchester '73
Director: Anthony Mann
Stars: James Stewart, Shelley Winters, Dan Duryea
Local Locations: Old Tucson Studios, Empire Ranch

1951

The Last Outpost
Director: Lewis R. Foster
Stars: Ronald Reagan, Rhonda Fleming
Local Locations: Old Tucson Studios

1952

Pony Soldier
Director: Joseph M. Newman
Stars: Tyrone Power, Cameron Mitchell, Thomas Gomez
Local Locations: Sedona

1953

Arena
Director: Richard Fleischer
Stars: Gig Young, Jean Hagen, Polly Bergen
Local Locations: Tucson's rodeo grounds

War Arrow
Director: George Sherman
Stars: Maureen O'Hara, Jeff Chandler
Local Locations: Empire Ranch

1954

Broken Lance
Director: Edward Dmytryk
Stars: Spencer Tracy, Robert Wagner, Jean Peters
Local Locations: Circle Z Ranch, Empire Ranch

Johnny Guitar
Director: Nicholas Ray
Stars: Joan Crawford, Sterling Hayden, Mercedes McCambridge
Local Locations: Sedona

1955

Oklahoma!
Director: Fred Zinnemann
Stars: Gordon MacRae, Shirley Jones
Local Locations: San Rafael Ranch, Agua Linda Farm, Empire Ranch

1956

Bus Stop
Director: Joshua Logan
Stars: Marilyn Monroe, Don Murray, Arthur O'Connell
Local Locations: Phoenix

A Kiss Before Dying
Director: Gerd Oswald
Stars: Robert Wagner, Joanne Woodward
Locations: Downtown Tucson

The Searchers
Director: John Ford
Stars: John Wayne, Jeffrey Hunter, Vera Miles
Local Locations: Monument Valley

1957

3:10 to Yuma
Director: Delmer Daves
Stars: Glenn Ford, Van Heflin, Felicia Farr
Local Locations: Sedona, Triangle T Guest Ranch, Empire Ranch

The Way to the Gold
Director: Robert D. Webb
Stars: Jeffrey Hunter, Sheree North, Barry Sullivan
Local Locations: Arizona State Prison (Florence)

1959

Last Train from Gun Hill
Director: John Sturges
Stars: Kirk Douglas, Anthony Quinn, Carolyn Jones
Local Locations: Old Tucson Studios, Empire Ranch

Rio Bravo
Director: Howard Hawks
Stars: John Wayne, Dean Martin, Ricky Nelson
Local Locations: Old Tucson

1960

Psycho
Director: Alfred Hitchcock
Stars: Anthony Perkins, Vera Miles, Janet Leigh
Local Locations: Orpheum Lofts (downtown Phoenix)

1962

How the West Was Won
Directors: John Ford, Henry Hathaway, George Marshall
Stars: Henry Fonda, Gregory Peck, James Stewart
Local Locations: Superior

Lilies of the Field
Director: Ralph Nelson
Stars: Sidney Poitier, Lilia Skala, Lisa Mann
Local Locations: Northeast Tucson

1963

McLintock!
Director: Andrew V. McLaglen
Stars: John Wayne, Maureen O'Hara, Patrick Wayne
Local Locations: Nogales, Old Tucson, Patagonia

1965

The Rounders
Director: Burt Kennedy
Stars: Glenn Ford, Henry Fonda
Local Locations: Sedona

1967

Hombre
Director: Martin Ritt
Stars: Paul Newman, Fredric March, Richard Boone
Local Locations: Old Tucson Studios, Empire Ranch

1968

Lonesome Cowboys
Directors: Andy Warhol, Paul Morrissey
Stars: Viva, Tom Hompertz, Louis Waldon
Local Locations: Oracle

Stay Away, Joe
Director: Peter Tewksbury
Stars: Elvis Presley, Burgess Meredith, Joan Blondell
Local Locations: Sedona

1969

Charro!
Director: Charles Marquis Warren
Stars: Elvis Presley, Ina Balin, Victor French
Local Locations: Apacheland Movie Ranch

Easy Rider
Director: Dennis Hopper
Stars: Peter Fonda, Dennis Hopper, Jack Nicholson
Local Locations: Flagstaff, Monument Valley

Riot
Director: Buzz Kulik
Stars: Jim Brown, Gene Hackman, Mike Kellin
Local Locations: Arizona State Prison

Young Billy Young
Director: Burt Kennedy
Stars: Robert Mitchum, Angie Dickinson, Robert Walker Jr.
Local Locations: Old Tucson

1970

Monte Walsh
Director: William A. Fraker
Stars: Lee Marvin, Jeanne Moreau, Jack Palance
Local Locations: Mescal, Empire Ranch

Rio Lobo
Director: Howard Hawks
Stars: John Wayne, Jorge Rivero, Jennifer O'Neill
Local Locations: Old Tucson Studios

1971

Billy Jack
Director: Tom Laughlin
Stars: Tom Laughlin, Delores Taylor, Clark Howat
Local Locations: Prescott

Pocket Money
Director: Stuart Rosenberg
Stars: Paul Newman, Lee Marvin
Local Locations: Tucson, Empire Ranch

Wild Rovers
Director: Blake Edwards
Stars: William Holden, Ryan O'Neal, Karl Malden
Local Locations: San Rafael Ranch, Empire Ranch

1972

Life and Times of Judge Roy Bean
Director: John Huston
Stars: Paul Newman, Roddy McDowell, Satcy Keach
Local Locations: Old Tucson Studios, Mescal

Night of the Lepus
Director: William F. Claxton
Stars: Stuart Whitman, Janet Leigh, Rory Calhoun
Local Locations: Empire Ranch

1974

Alice Doesn't Live Here Anymore
Director: Martin Scorsese
Stars: Ellen Burstyn, Kris Kristofferson, Harvey Keitel, Jodie Foster
Local Locations: Tucson's Wilmot Road and Speedway (the Monterey Village sign), the Chicago Music Store, Pima County Juvenile Court Center, Amado

1975

Posse
Director: Kirk Douglas
Stars: Kirk Douglas, Bruce Dern, Bo Hopkins
Local Locations: Old Tucson Studios, Empire Ranch

1976

The Last Hard Men
Director: Andrew V. McLaglen
Stars: Charlton Heston, James Coburn, Barbara Hershey
Local Locations: Old Tucson Studios, Empire Ranch

The Outlaw Josey Wales
Director: Clint Eastwood
Stars: Clint Eastwood, Sondra Locke, Chief Dan George
Local Locations: Empire Ranch, Mescal, Old Tucson, Lake Powell

A Star Is Born
Director: Frank Pierson
Stars: Barbra Streisand, Kris Kristofferson, Gary Busey
Local Locations: Empire Ranch, Tucson Arena, downtown Tucson and Tempe

1977

The Gauntlet
Director: Clint Eastwood
Stars: Clint Eastwood, Sondra Locke, Pat Hingle
Local Locations: Phoenix

1979

The Frisco Kid
Director: Robert Aldrich
Stars: Gene Wilder, Harrison Ford
Local Locations: Old Tucson Studios

The Sacketts
Director: Robert Totten
Stars: Sam Elliot, Tom Selleck
Local Locations: Old Tucson Studios

1980

Stir Crazy
Director: Sidney Poitier
Stars: Gene Wilder, Richard Pryor
Local Locations: Florence, the Tucson Rodeo Grounds, Pima Community College West Campus and downtown Tucson

Tom Horn
Director: William Wiard
Stars: Steve McQueen, Linda Evans, Richard Farnsworth
Local Locations: Empire Ranch, Mescal, Old Tucson

1983

Revenge of the Nerds
Director: Jeff Kanew
Stars: Robert Carradine, Anthony Edwards
Local locations: University of Arizona (Bear Down Gym, Arizona Stadium and campus frat houses), Scottish Rite Cathedral

Star Wars Episode VI: Return of the Jedi
Director: Richard Marquand
Stars: Mark Hamill, Harrison Ford, Carrie Fisher
Local Locations: Yuma

1984

Cannonball Run II
Director: Hal Needham
Stars: Burt Reynolds, Dom DeLuise
Local Locations: Old Tucson Studios, Arizona State School for the Deaf and Blind campus

The Karate Kid
Director: John G. Avildson
Stars: Ralph Macchio, Elizabeth Shue
Local Locations: Phoenix, Sedona, Oak Creek Canyon

1985

Murphy's Romance
Director: Martin Ritt
Stars: Sally Field, James Garner, Corey Haim
Local Locations: Florence

1986

Three Amigos
Director: John Landis
Stars: Steve Martin, Chevy Chase, Martin Short
Local Locations: Old Tucson Studios, Coronado National Forest

1987

Can't Buy Me Love
Director: Steve Rash
Stars: Patrick Dempsey, Seth Green
Local Locations: Tucson High School, Tucson Mall, Pima Air and Space Museum

Raising Arizona
Directors: Joel Coen, Ethan Coen
Stars: Nicolas Cage, Holly Hunter, Trey Wilson
Local Locations: Phoenix, the Reata Pass Steakhouse, the Phoenician resort, city hall

1988

Midnight Run
Director: Martin Brest
Stars: Robert De Niro, Charles Grodin, Yaphet Kotto
Local Locations: Flagstaff

1989

Bill and Ted's Excellent Adventure
Director: Stephen Herek
Stars: Keanu Reeves, Alex Winter, George Carlin
Local Locations: Phoenix

1990

Back to the Future Part III
Director: Robert Zemeckis
Stars: Michael J. Fox, Christopher Lloyd, Mary Steenburgen
Local Locations: Monument Valley

Days of Thunder
Director: Tony Scott
Stars: Tom Cruise, Nicole Kidman, Robert Duvall
Local Locations: Phoenix

1991

Grand Canyon
Director: Lawrence Kasdan
Stars: Danny Glover, Kevin Kline, Steve Martin
Local Locations: Grand Canyon National Park

1993

Maverick
Director: Richard Donner
Stars: Mel Gibson, James Garner, Jodie Foster
Local Locations: Page (Lake Powell, Lees Ferry, Marble Canyon)

Natural Born Killers
Director: Oliver Stone
Stars: Woody Harrelson, Juliet Lewis, Robert Downey Jr.
Local Locations: Winslow, Holbrook, Monument Valley

Posse
Director: Mario Van Peebles
Stars: Mario Van Peebles, Stephen Baldwin, Charles Lane
Local Locations: Florence, Empire Ranch

The Quick and the Dead
Director: Sam Raimi
Stars: Sharon Stone, Gene Hackman, Leonardo DiCaprio
Local Locations: Mescal

Tombstone
Director: George P. Cosmatos
Stars: Kurt Russell, Val Kilmer, Sam Elliott, Bill Paxton
Local Locations: Tucson, Mescal

1994

Arizona Dream
Director: Emir Kusturica
Stars: Jerry Lewis, Faye Dunaway, Johnny Depp
Local Locations: Patagonia, Douglas

Forrest Gump
Director: Robert Zemeckis
Stars: Tom Hanks, Robin Wright, Gary Sinise
Local Locations: Flagstaff (Twin Arrows Trading Post), Monument Valley

The Getaway
Director: Roger Donaldson
Stars: Alec Baldwin, Kim Basinger, Michael Madsen
Local Locations: Yuma, Prescott

A Low Down Dirty Shame
Director: Keenen Ivory Wayans
Stars: Keenen Ivory Wayans, Jada Pinkett
Local Locations: Phoenix, Scottsdale (Scottsdale Galleria)

1995

Boys on the Side
Director: Herbert Ross
Stars: Drew Barrymore, Whoopi Goldberg, Mary-Louise Parker
Local Locations: Tucson General Hospital, Teatro Carmen, Tucson's Elks Club

Broken Arrow
Director: John Woo
Stars: John Travolta, Christian Slater, Samantha Mathis
Locations: Page (Marble Canyon)

Flirting with Disaster
Director: David O. Russell
Stars: Ben Stiller, Patricia Arquette, Mary Tyler Moore
Local Locations: Phoenix, Scottsdale, Carefree, Tucson, Marana

Waiting to Exhale
Director: Forest Whitaker
Stars: Whitney Houston, Angela Bassett, Loretta Devine
Local Locations: Phoenix

1996

Blue Rodeo
Director: Peter Werner
Stars: Ann-Margret, Kris Kristofferson
Local Locations: Tucson

Contact
Director: Robert Zemeckis
Stars: Jodie Foster, Matthew McConaughey, Angela Bassett
Local Locations: Navajo Nation (Canyon de Chelly)

Jerry Maguire
Director: Cameron Crowe
Stars: Tom Cruise, Cuba Gooding Jr., Renée Zellweger
Local Locations: Phoenix

Tin Cup
Director: Ron Shelton
Stars: Kevin Costner, Rene Russo, Don Johnson, Cheech Marin
Local locations: Hotel Congress, the Tubac Golf Resort and Spa

U-Turn
Director: Oliver Stone
Stars: Nick Nolte, Sean Penn, Jennifer Lopez, Billy Bob Thornton
Local Locations: Superior, Globe, Miami

1997

Buffalo Soldiers
Director: Charles Haid
Stars: Danny Glover, Mykelti Williamson
Local Locations: Mescal, St. David, Texas Canyon, Cochise Stronghold, Willcox Playa

Fear and Loathing in Las Vegas
Director: Terry Gilliam
Stars: Johnny Depp, Benicio Del Toro, Gary Busey
Local Locations: Kingman

Fools Rush In
Director: Andy Tennant
Stars: Matthew Perry, Salma Hayek
Local Locations: Grand Canyon National Park

The Postman
Director: Kevin Costner
Stars: Kevin Costner, Will Patton, Olivia Williams
Local Locations: Sahuarita, Amado, Nogales, Sopori Ranch, Agua Linda Farm, Tucson

1998

Three Kings
Director: David O. Russell
Stars: George Clooney, Mark Wahlberg, Ice Cube
Local Locations: Casa Grande, Tucson, Sacaton Mine

Wild Wild West
Director: Barry Sonnenfeld
Stars: Will Smith, Kevin Kline, Kenneth Branagh
Local Locations: Canyon de Chelley, Monument Valley, Nogales, Amado

1999

Almost Famous
Director: Cameron Crowe
Stars: Billy Crudup, Kate Hudson, Anna Paquin, Bijou Phillips
Local Locations: Old Ajo Highway, I-19, Amado, Tumacacori, Tucson

2000

Evolution
Director: Ivan Reitman
Stars: David Duchovny, Julianne Moore, Dan Aykroyd
Local Locations: Page

Planet of the Apes
Director: Tim Burton
Stars: Mark Wahlberg, Helena Bonham Carter, Tim Roth
Local Locations: Page (Lake Powell)

Traffic
Director: Steven Soderbergh
Stars: Benicio Del Toro, Michael Douglas
Local Locations: Nogales and Nogales Sonora

2001

The Banger Sisters
Director: Bob Dolman
Stars: Susan Sarandon, Goldie Hawn, Geoffrey Rush, Erika Christensen
Local Locations: Phoenix

The Scorpion King
Director: Chuck Russell
Stars: Dwayne "The Rock" Johnson, Michael Clarke Duncan
Local Locations: Yuma

2002

Confessions of a Dangerous Mind
Director: George Clooney
Stars: George Clooney, Drew Barrymore, Sam Rockwell, Julia Roberts, Brad Pitt
Local Locations: White Stallion Ranch, Nogales Arizona, Nogales Sonora

The Imposter
Director: Gary Fleder
Stars: Gary Sinise, Madeline Stowe
Local Locations: Tempe, Phoenix

2003

Mona Lisa Smile
Director: Mike Newell
Stars: Julia Roberts, Kirsten Dunst, Julia Stiles
Local Locations: Parker (Highway 60 and 72 near Vicksburg)

Spin
Director: James Redford
Stars: Rubén Blades, Dana Delany, Stanley Tucci
Local Locations: Tucson, Arivaca, Sopori Ranch

2004

Arizona Summer
Director: Joey Travolta
Writer: Bill Blair
Stars: Gemini Barnett, Brent Blair, Christy Blair
Local Locations: Prescott

2005

Jarhead
Director: Sam Mendes
Stars: Jake Gyllenhaal, Jamie Foxx, Scott MacDonald, Peter Sarsgaard
Local Locations: Yuma

Transamerica
Director: Duncan Tucker
Stars: Felicity Huffman, Kevin Zegers
Local Locations: Black Canyon City, Paradise Valley, Phoenix, Prescott, Wickenburg

2006

Little Miss Sunshine
Directors: Jonathan Dayton, Valerie Faris
Stars: Greg Kinnear, Alan Arkin, Toni Collette, Steve Carell
Local Locations: Chandler, Flagstaff, Phoenix

Wild Seven
Director: James M. Hausler
Stars: Richard Roundtree, Robert Loggia, Robert Forster
Local Locations: Arizona State Prison

2007

Into the Wild
Director: Sean Penn
Stars: Emile Hirsch, Marcia Gay Harden, Catherine Keener
Local Locations: Yuma

The Kingdom
Director: Peter Berg
Stars: Jamie Foxx, Chris Cooper, Jennifer Garner
Local Locations: Phoenix

2008

Jolene
Director: Dan Ireland
Stars: Jessica Chastain, Frances Fisher, Rupert Friend, Dermot Mulroney
Local Locations: Phoenix Sky Harbor, Scottsdale, Cave Creek and Prescott

2009

Away We Go
Director: Sam Mendes
Stars: John Krasinski, Maya Rudolph, Jeff Daniels, Maggie Gyllenhaal
Local Locations: Tucson

Ingenious
Director: Jeff Balsmeyer
Stars: Dallas Roberts, Jeremy Renner, Ayelet Zurer
Local Locations: Downtown Tucson

Middle Men
Director: George Gallo
Stars: Luke Wilson, Giovanni Ribisi, Gabriel Macht
Local Locations: Phoenix

2012

Goats
Director: Christopher Neil
Stars: David Duchovny, Vera Farmiga
Local Locations: Downtown Tucson, Catalina Foothills

2013

The Hangover Part III
Director: Todd Phillips
Stars: Bradley Cooper, Zach Galifianakis, Ed Helms

The Lone Ranger
Director: Gore Verbinski
Stars: Johnny Depp, Armie Hammer, William Fichtner
Local Locations: Monument Valley

TELEVISION

Gunsmoke (1955–75)
Stars: James Arness, Milburn Stone, Amanda Blake
Local Locations: Old Tucson Studios

26 Men (1957–59)
Stars: Tristram Coffin, Kelo Henderson, Hal Hopper
Local Locations: Cudia City

Bonanza (1959–73)
Stars: Lorne Greene, Michael Landon, Dan Blocker
Local Locations: Old Tucson Studios

The Dick Van Dyke Show (1961–66)
Creator: Carl Reiner
Stars: Dick Van Dyke, Mary Tyler Moore, Rose Marie
Local Locations: Carefree Studios

The High Chaparral (1967–71)
Creator: David Dortort
Stars: Leif Erickson, Cameron Mitchell, Henry Darrow
Local Locations: Old Tucson Studios

Run, Simon, Run (1970)
Director: George McCowan
Stars: Burt Reynolds, Inger Stevens, Royal Dano
Local Locations: Arizona State Prison

Petrocelli (1974–76)
Creators: Harold Buchman, Sidney J. Furie
Stars: Barry Newman, Susan Howard, Albert Salmi
Local Locations: Downtown Tucson

Little House on the Prairie (1974–83)
Creator: Michael Landon
Stars: Melissa Gilbert, Michael Landon, Lindsay Greenbush
Local Locations: Old Tucson Studios

The Young Riders (1989–92)
Creator: Ed Spielman
Stars: Stephen Baldwin, Josh Brolin, Ty Miller
Local Locations: Bisbee, Old Tucson Studios, Empire Ranch

Geronimo (1993)
Director: Roger Young
Writer: J.T. Allen
Stars: Joseph Runningfox, Nick Ramus, Michelle St. John
Local Locations: Empire Ranch

No One Would Tell (1996)
Director: Noel Nosseck
Stars: Fred Savage, Candace Cameron
Local Locations: Phoenix, Scottsdale, Mesa (Saguaro Lake)

An Unfinished Affair (1996)
Director: Rod Hardy
Stars: Jennie Garth, Tim Matheson
Local Locations: Downtown Tucson

30 Days (2005–)
Creator: Morgan Spurlock
Stars: Morgan Spurlock
Local Locations: Sedona (Schnebly Hill Road, downtown)

Desperation (2006)
Director: Mick Garris
Stars: Tom Skerritt, Steven Weber, Annabeth Gish
Local Locations: Bisbee, downtown Tucson

SOURCES

Abel, Barbara. "Film Wrangle Has Happy Ending; UA to Allow Nerds on Campus." *Tucson Citizen*, December 17, 1983.

Allen, Lee. "'Film-Friendly' Tucson Is Still a Good Location for Shoots, and the Film Office Aims to Prove It with Films, Commercials, TV." *Inside Tucson Business* 18, no. 2 (June 16, 2008): 7.

———. "'High Chaparral' Reunion Recalls What Was: Shows What Can Still Be." *Inside Tucson Business* 19, no. 21 (October 26, 2009): 3.

Anderson, Parker. *The Elks Opera House*. Charleston, SC: Arcadia Publishing, 2012.

———. Personal interview, August 2, 2013.

Apacheland. http://www.apacheland.com.

Arizona Daily Star. "Gay Desperado Filmed in Tucson, Gets Many Chuckles." October 1, 1936.

———. "Say Goodbye to Eclair Co." January 22, 1915.

———. "Wright Novel Features Fox Rodeo Program." December 27, 1934.

Arizona International Film Festival. "About." http://www.filmfestivalarizona.com.

Besich, Mark A. "Motion Picture Office Is a Moneymaker for Arizona." *Winslow* [AZ] *Mail*, May 18, 1990.

Bissinger, Buzz. "Inventing Ford Country." *Vanity Fair* 583 (2009): 218.

Born, Dewey E. "The First Movies in Prescott." N.p., n.d. Academic paper.

Bowen, Shannon L. "Raising Arizona." *Hollywood Reporter* 404, no. 8 (2008): M1.

Boyd, David. "Paranoid Projections: Self and Society in 'The Searchers' and 'Psycho.'" *Australasian Journal of American Studies* 3, no. 2 (1984): 49–57.

Boyer, Jay. "Film Making in Prescott." *Diversions* (Winter 1963): 16–19.

Bradshaw, Bob. *Westerns of the Red Rock Country: 43 Movies Filmed in Sedona.* Sedona, AZ: Bradshaw Color Studios, 1991.

Bradstock, Phil. Personal interview, May 28, 2013.

Bricca, Jacob. Personal interview, December 8, 2013.

Bullis, Don. *The New and Completely Revised Old West Trivia Book.* Los Ranchos, NM: Rio Grande Books, 2009.

Carney, Jason. Personal interview, August 26, 2013.

Causey, Frances. Personal interview, August 13, 2013.

Clinco, Demion. Personal interview, March 18, 2013.

Corliss, Richard. "Rootless People—RAISING ARIZONA, Directed by Joel Coen; Screenplay by Ethan Coen and Joel Coen." *Time* 129, no. 12 (1987): 86.

Craig, Dustinn. Personal interview, September 25, 2013.

Cunningham, Doug. *Tombstone & Beyond: Guide to Movie Locations in Arizona.* Gilbert, AZ: Faraway Productions, 2004.

Davis, Ronald L. "Paradise Among the Monuments: John Ford's Vision of the American West." *Magazine of Western History* 45, no. 3 (1995): 48–63.

Donovan, Bill. "Action! In Navajo Nation." *Arizona Republic*, September 7, 1993, G1.

Eppinga, Jane. *Nogales: Life and Times on the Frontier.* Charleston, SC: Arcadia Publishing, 2002.

Falk, Margaret. "Old Fox New Tricks." *Tucson Lifestyle* (September 2000): 41–44.

Flagstaff Mountain Film Festival. "Festival History." http://www.flagstaffmountainfilms.org/about-fmff/festival-history.

Flood, Timothy. Personal interview, June 12, 2013.

Fox Tucson Theatre. "History." http://www.foxtucsontheatre.org/history.

Franzi, Emil. Personal interview, November 5, 2013.

Gammons, Jay. Personal interview, October 25, 2013.

Gordon, William A. *Shot on This Site.* New York: Carol Publishing Group, 1995.

Greenwald, Martha. "Edward Hopper Watching the Petrified Forest." *Poetry Foundation* 170, no. 4 (1997): 197–98.

Gregg, Ken. Personal interview, October 31, 2013.

Hall, George C. "The First Moving Picture in Arizona: Or Was It? The Tragic Tale of C.L. White's Marvelous Projectoscope Show in Arizona and New Mexico Territories, 1897–1898." *Film History* 3, no. 1 (1989): 1–9.

Hatfield, David. "Arizona Beat Canada in Playing Nevada." *Inside Tucson Business* 15, no. 47 (May 2006): 10.

Hedler, Ken. "Certainly Not Devoid of Celluloid." *Tri-City Business News*, January 7, 2004.

Hofstetter, Eric. Personal interview, November 12, 2013.

Hogue, RuthAnn. "Reel Letdown Locally." *Arizona Daily Star*, October 19, 1999.

Hufford, Kenneth. "On Location: The Lubin Motion Picture Company in Arizona, 1912." Thesis, University of Arizona, 1967.

Inside Tucson Business. "Incentives Can't Revive Westerns" (September 7, 2012): 20.

Internet Movie Database. http://www.imdb.com.

Jaeger, Ernest. "Precious Knowledge: Arizona's Battle Over Ethnic Studies." *Library Journal* 138, no. 14 (2013): 79.

Jenkins, Jennifer L. Personal interview, July 20, 2013.

Jennings, John. "On Location at Tucson High." *Tucson Citizen*, January 13, 1987.

Johnson-Schmit, Andrew. Personal interview, September 3, 2013.

Jones, Malcolm. "The Mother of All Horror Films." *Newsweek* 155, no. 3 (January 18, 2010): 58–61.

Kelly, Tim. "The Classic Westerner." *Phoenix Point West* (May 1964): 20–28.

Kowall Woal, Linda, and Michael Woal. "Romaine Fielding's Real Westerns." *Journal of Film and Video* 47, no. 1/3 (1995): 7–25.

Kucharo, Michael. Personal interview, November 10, 2013.

LaDue, John. "Film in Southern Arizona: A Brief History." N.p., 1981. Academic paper.

Laws, Scott. Personal interview, December 10, 2013.

Lawton, Paul J. *Old Tucson Studios.* Charleston, SC: Arcadia Publishing, 2008.

Maddox, Ric. Personal interview, November 29, 2013.

Makino, Yuri. Personal interview, October 18, 2013.

Marshall, Wendy L. "Arizona: A True Star." *Arizona Republic*, January 23, 1994, F8.

Mascelli, Joseph V. "Western Saga." *International Photographer* (November 1948): 5.

Mattern, Hal. "State Catches Eye of Hollywood's Cameras." *Arizona Republic*, September 16, 1990, B2.

McDonald, Kathy A. "Monumental Deals." *Daily Variety* 302, no. 10 (2009).

McGinnis, Eren. Personal interview, November 15, 2013.

McLain, Lorin. "Jolene." *Prescott Daily Courier*, May 8, 2008, 1A.

McNeill, Joe. *Arizona's Little Hollywood: Sedona and Northern Arizona's Forgotten Film History, 1923–1973*. Sedona, AZ: Northedge & Sons, 2010.

Miles, Douglas. Personal interview, September 15, 2013.

Miller, Marty. Personal interview, October 11, 2013.

Murray, John A. *Cinema Southwest: An Illustrated Guide to the Movies and Their Locations*. Flagstaff, AZ: Northland Publishing, 2000.

Navajo-Hopi Observer. "Native American Filmmakers at Forefront of Film." November 20, 2011.

Nicholson, Mervyn. "Alfred Hitchcock Presents Class Struggle." *Monthly Review: An Independent Socialist Magazine* 63, no. 7 (2011): 33.

Ohrling, Michael. Personal interview, November 25, 2013.

Old Tucson. "Film History." http://oldtucson.com/films-producers-directors/film-history.

Perrottet, Tony. "Behind the Scenes in Monument Valley." *Smithsonian* 40, no. 11 (2010): 72.

Phoenix Convention Center. "Orpheum Theatre." www.phoenixconventioncenter.com/venues/orpheum-theatre.

Porier, Shar. "Allison Otto Plans to Feature Bisbee in Documentary." *Sierra Vista Herald*, August 24, 2013, 10.

Prescott Elks Theatre. "History." http://www.elksoperahouse.com.

Rauso, Philip. Personal interview, July 17, 2013.

Reid, Chris. Personal interview, June 9, 2013.

Repp, Thomas Arthur. "Forrest Gump." *American Road* 7, no. 4 (2009): 57.

Reyes, Rodrigo. Personal interview, January 6, 2013.

Royston, Innes. Personal interview, November 29, 2013.

Ruelas, Richard. *Thanks for Tuning In*. Chicago: Boffo Books, 2006.

Rushton, Linda. Personal interview, March 12, 2013.

Sargent, Andrew. "Building 'Precious Knowledge': An Interview with Documentary Filmmaker Eren Isabel McGinnis." *Melus* 36, no. 1 (Spring 2011): 195–217.

Scully, Chris. Personal interview, October 28, 2013.

Sedona International Film Festival. "History." http://www.sedonafilmfestival.org.

Sharp, Lisa. Personal interview, November 11, 2013.

Shelton, Bob. Personal interview, June 12, 2013.

Shiff, Anne. Personal interview, April 13, 2013.

Shively, JoEllen. "Cowboys and Indians: Perceptions of Western Films Among American Indians and Anglos." *American Sociological Review* 57, no. 6 (December 1992): 725–34.

Simpson, Claudette. "Tom Mix." *Prescott Courier*, March 15, 1979.

Simpson, Corky. "Tucson, Poitier Scored with Lilies of the Field." *Tucson Citizen*, September 19, 2003.

Simpson, Paul. *The Rough Guide to Westerns*. London: Rough Guides, 2006.

Skinner, M. Scot. "Lights, Camera, Arizona!" *Arizona Daily Star*, April 10, 2011.

———. "20 Significant Westerns Made in Arizona." *Arizona Daily Star*, April 10, 2011.

Smith, Nicholas. "Is It Lights Out for Tucson Film?" *Inside Tucson Business* 19, no. 5 (2009): 3.

Soyk, Jeff. Personal interview, November 27, 2013.

Stanton, Bette L. *Where God Put the West: Movie Making in the Desert, a Moab-Monument Valley Movie History*. Moab, UT: Canyonlands Natural History Association, 2003.

Stephenson, Helen. Personal interview, October 25, 2013.

Stier, Kenny. *The First Fifty Years of Sound Western Movie Locations, 1929–1979*. Rialto, CA: Corriganville Press, 2006.

Stovall, Tommy. Personal interview, September 10, 2013.

Stratford, Herb. "Loft Cinema Brings Film Festival Experience to Tucson." *Inside Tucson Business* 22, no. 23 (2012): 12.

———. "Mexican Films Showcased at Tucson Cine Festival." *Inside Tucson Business* 22, no. 43 (2013): 14.

Taylor, Yvonne. Personal interview, November 23, 2013.

Teachout, Terry. "The Trouble with Alfred Hitchcock." *Commentary* 127, no. 2 (February 2009): 43–46.

Thompson, Paul. Personal interview, September 13, 2013.

Towne, Douglas. "Spaghetti Western." *Phoenix Magazine* (September 2012): 50.

Trevillyan, Janeen. Personal interview, September 30, 2013.

Tucson Citizen. "Miss Jean Harlow Is Deputy Sheriff." September 21, 1933.

The University of Arizona College of Fine Arts. "Tucson Cine Mexico." http://tucsoncinemexico.org.

Van Dyke, Dick. *My Lucky Life in and Out of Show Business*. New York: Crown Publishing Group, 2011.

Villarreal, Phil. "Starring Tucson." *Arizona Daily Star*, June 24, 2007, E9.

Walther, Larry. Personal interview, September 20, 2013.

Webster, Guy. "Arizona's Where Action! Is." *Arizona Republic*, February 11, 1990, F4.

Westover, Victoria. Personal interview, September 22, 2013.

Wild West 22, no. 1. "Monumental Vision" (June 2009): 54–60.

Wiley Whetzel, Mary. *Echoes Down the Centuries.* Lincoln, NE: iUniverse, 2007.

Williams, Marco. Personal interview, December 20, 2013.

Woodburn, David. "Film Office: No 'Desperation' Mode." *Inside Tucson Business* 14, no. 25 (2004): 1.

Wright, Will. *Sixguns and Society: A Structural Analysis of the Western.* Berkeley: University of California Press, 1977.

INDEX

ABOUT THE AUTHOR

Lili DeBarbieri is a nonfiction author, librarian and travel expert. Lili's notable, best-selling debut book, *A Guide to Southern Arizona's Historic Farms and Ranches*, was named a New Mexico/ Arizona Book Awards finalist. An accomplished and versatile writer, her work has appeared in a diverse range of publications over the years, including the forthcoming scholarly work *The Utah Prairie Dog*. Lili is a local stringer for Agence France-Presse, an international news agency, and has served as contributing editor of *Ethical Traveler*. A Philadelphia native, she lives in Tucson, Arizona.